# Concrete

# Art

Art work by Eva Bauer

Copyright © 2016 Eva Bauer

Karlstr.16, 78073 Bad Dürrheim, Germany

Cover design, layout, video, sound, art work, photos by Eva Bauer

All rights reserved.

VG BILD-KUNST, Germany

ISBN: 1534820078
ISBN-13: 978-1534820074

## Acknowledgement

Wikipedia, text about **Concrete Art**
Dr. Hanne Weskott, text **Painting with Numbers,**
translated by H. Askew

From Wikipedia, the free encyclopedia:

**Concrete art** is an art movement with a strong emphasis on abstraction. The artist Theo van Doesburg, closely associated with the De Stijl art movement, coined the term "concrete art" as he in 1930 founded the group Art Concret and articulated its features in a manifesto titled "The Basis of Concrete Art", signed by four other artists of the group. The manifesto explained that the resultant art should be non-referential insofar as its components should *not* refer to, or allude to, the entities normally encountered in the natural, visible world. This is a distinction from abstraction generally. In a more general sense "abstract art" could and often does include the "abstraction of forms in nature".[2] But "concrete art" was intended to emanate "directly from the mind" and consequently to be more "cerebral"[2] than abstract art generally. Concrete art is often composed of basic visual features such as planes, colors, and forms.[3] "Sentiment" tends to be absent from concrete art.[2] The "hand" of the artist may be difficult to detect in finished works of concrete art; concrete art may appear, in some instances, to have been made by a machine.[3] Concrete art often has a core visual reference to geometry whereas more general abstract art may find its basis in the components of the natural world. A formulation of a description of concrete art might include a considerable reliance on the formal qualities of an artwork. Theo Van Doesburg's manifesto stated that art "should receive nothing from nature's formal properties or from sensuality or sentimentality. We want to exclude lyricism, dramaticism, symbolism, etc…."[4] In concrete art a mathematical equation can serve as a starting point. Concrete art can include painting and sculpture.[5]

The term was popularized by the artist Josef Albers, and the artist Max Bill further promoted the ideas associated with concrete art, organizing the first international exhibition in 1944.

## CONTENTS

| | | |
|---|---|---|
| 1 | Painting with Numbers | 10 |
| 2 | Works on canvas | 14 |
| 3 | Art Objects | 34 |
| 4 | Video Installations | 40 |
| 5 | Photography | 48 |
| 6 | Print Editions | 54 |
| 7 | About the Artist | 60 |
| 8 | Information on the art works | 62 |

A SELECTION OF
PAINTINGS
ART OBJECTS
VIDEO SOUND INSTALLATIONS
PHOTOGRAPHY
PRINT EDITIONS
BY THE ARTIST EVA BAUER

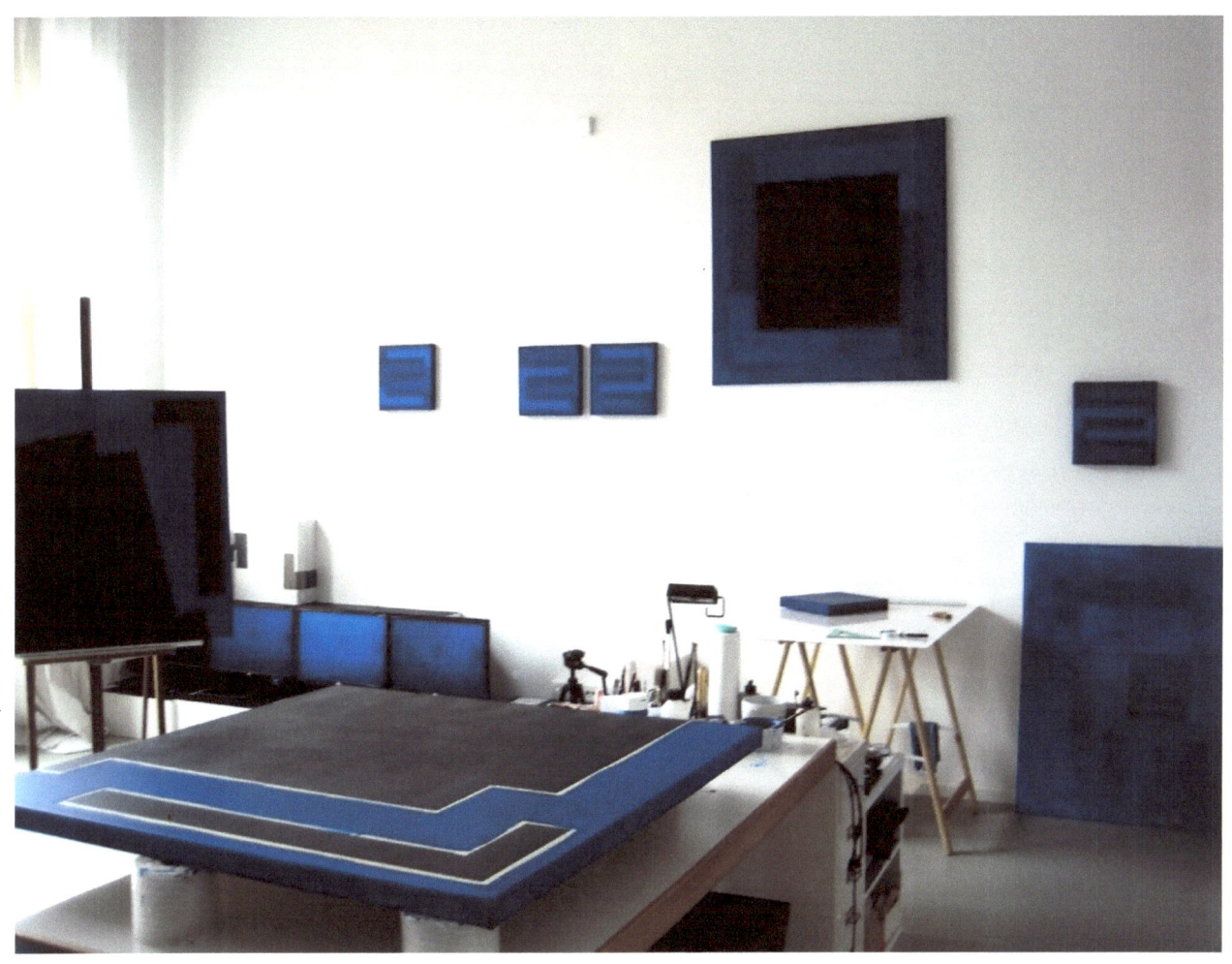

STUDIO BERLIN 2010 – THE BLUE PHASE

## Painting with Numbers

Painting by numbers has gone out of fashion. In any case, it restricts creativity enormously. After all, art is free and artists are only accountable to themselves. They are free to develop their creative powers without limitations. But in this sea of pictures and colors, there is a danger of going under. Artists therefore also search for a leitmotif in the labyrinth of creative possibilities. They create structures to give their work a distinctive character. For since art is free, it suffers from the compulsion to be innovative. But how can one create something new when art always concerns art and is therefore always confined to a closed system? Either one reduces the diversity of images to the essentials to the point of pure abstraction or one breaks through existing boundaries like DADA and surrealism or one takes the essential elements of existing art as a starting point for developing a new system, which directly leads to the referential art of today. But there is yet another way. This is the way of concrete art. For if art necessarily always concerns art, it can just as well reflect on its own means and eliminate everything that is alien to art, and therefore simply forget all the meanings and contents that are superimposed on it. Thus, a value is attached to a color in and of itself without any symbolic or allegorical meaning. And a form no longer describes a thing; a square is a square and a line a line. The background too does not become an illusionistic space, but rather remains a surface on which the colors and forms develop. However, this revolutionary approach went the same way as all other aging revolutions over the years: Breaking out of the system inevitably led to a new system and therefore again to a closed circle. The new was ultimately still only a pale imitation of the old and mutated into a mere variation. To escape this cycle, artists have invented other methods again and again. Some

utilize pure chance, others like Eva Bauer purposefully confront themselves with tasks in order to combat their own capriciousness with rigorous structures.

After a long artistic pause Eva Bauer started with numbers, which she uses as mere forms. She therefore does with numbers what Concrete Art has done with color and form: she negates any kind of meaning. The numbers can appear as positive or negative symbols, be repeated twice in a painting and form a new shape simply by changing their orientations and then unite with one another into a coherent whole. The astonishing thing about this playing with numbers is the incredible diversity that emerges, and also how convincingly this liberation of numbers from their meaning succeeds. One no longer perceives them as symbols for a certain quantity, but rather as pure structure in the initially white surface. This impression is further intensified in the *hidden numbers* series, since here the numbers are more or less covered by a grid of white bars. Thus, a lying eight is only vaguely perceived in gently curved, orange-colored fragments against a pink background. Compared with the extremely subdued white, the combination of orange and pink appears garishly vivid. Color is also utilized in all of its glowing facets in the *pixel numbers* series. Here again, the numbers determine the surface structure, though they are only set off as omissions; that is to say that the pixels, the points in the picture, don't form the number, but rather occupy the margins. And here again, a useful system is not only employed for another purpose, but rather as the structural foundation of a picture that is free from any functional connection. The pictures created in this way seem to be in the process of disappearing. Their presence is fragile because the colored elements in the picture seem to evade the middle.

A new visual element comes into the work of Eva Bauer via the use of *bar codes*, this system of stripes that has determined and pervaded our daily life like hardly anything else. Hidden in the bar code is information about our world of goods. But this is irrelevant for Eva Bauer's art. She uses this ubiquitous stripe system as a means of rhythmically structuring a two-color surface. The currently preferred color is orange; orange stripes on a white ground or white on an orange ground, sometimes wider, sometimes narrower, sometimes running all the way

through, sometimes ending in the picture, always arranged systematically, never purely arbitrarily. The result: seemingly overlapping picture halves and the suggestion of three-dimensionality. The stripes are also well-suited for paintings on three-dimensional objects like cubes where they run uninterrupted over the edges. There is also nothing to prevent a combination with numbers via omission or painting over. In this way, Eva Bauer expands her original minimalistic system and structures it more and more complexly. But it remains clear and controllable by the artist. She holds the reins of her work firmly in her hands. After all, one of the definitions of art is that it serves only one purpose – to order the chaos of life. Or in other words: if the world was clear, it wouldn't need art.

Written by Dr.Hanne Weskott, Malen mit Zahlen, 2006
translated by H. Askew

# WORKS ON CANVAS
## SINCE 2002

Description of all images on Page 62

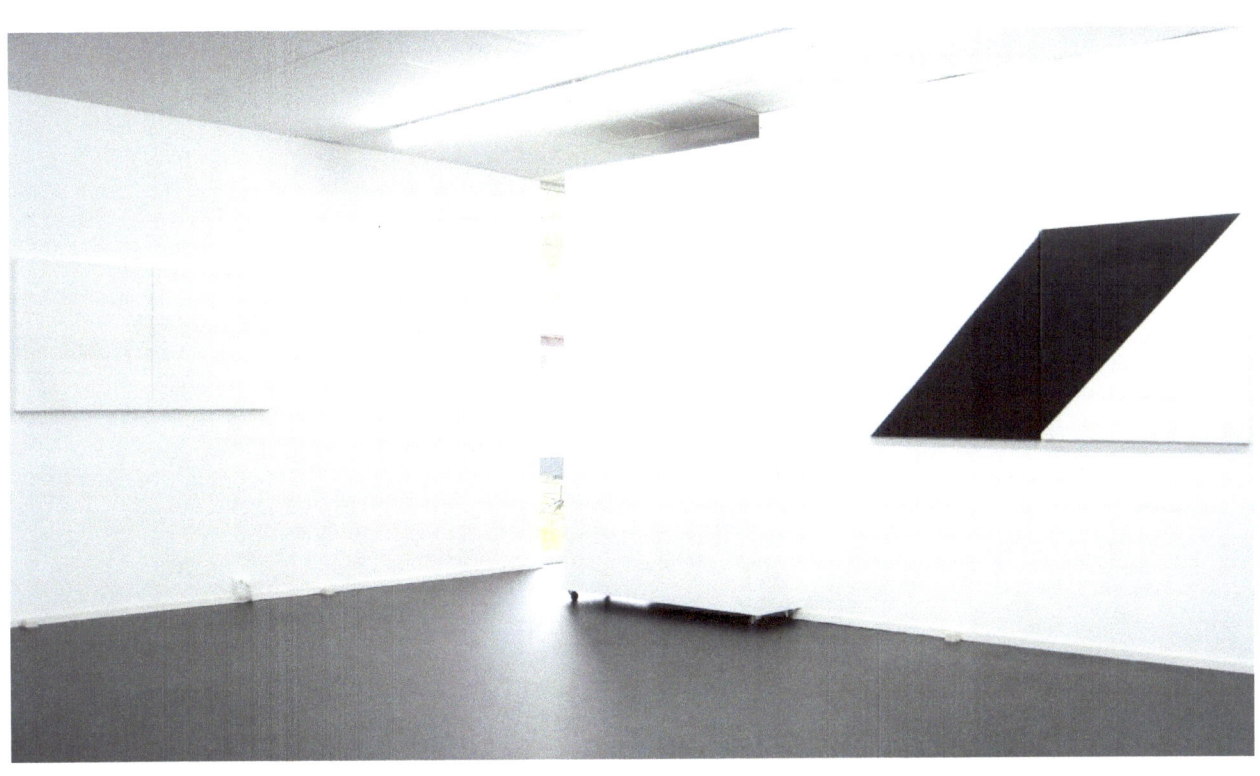

MODERN ART MUSEUM HÜNFELD, GERMANY, 2010

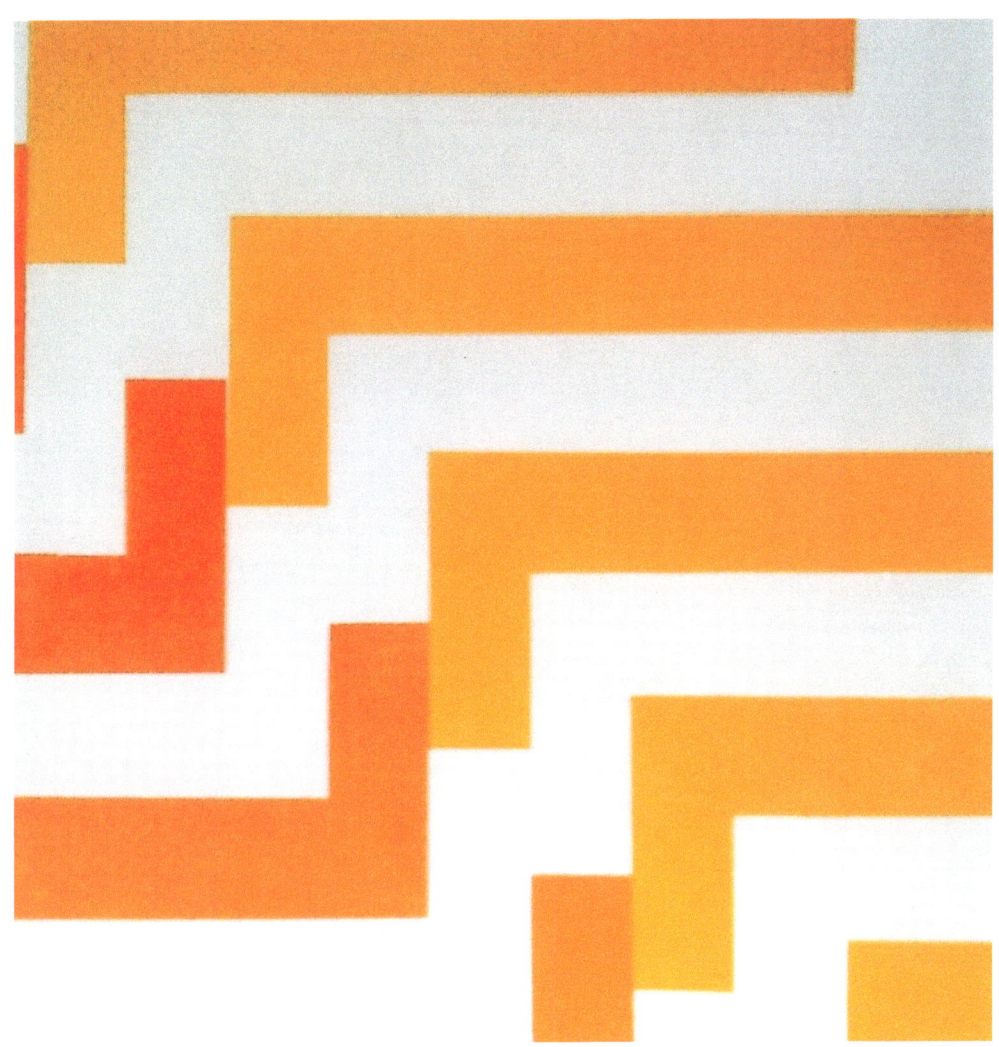

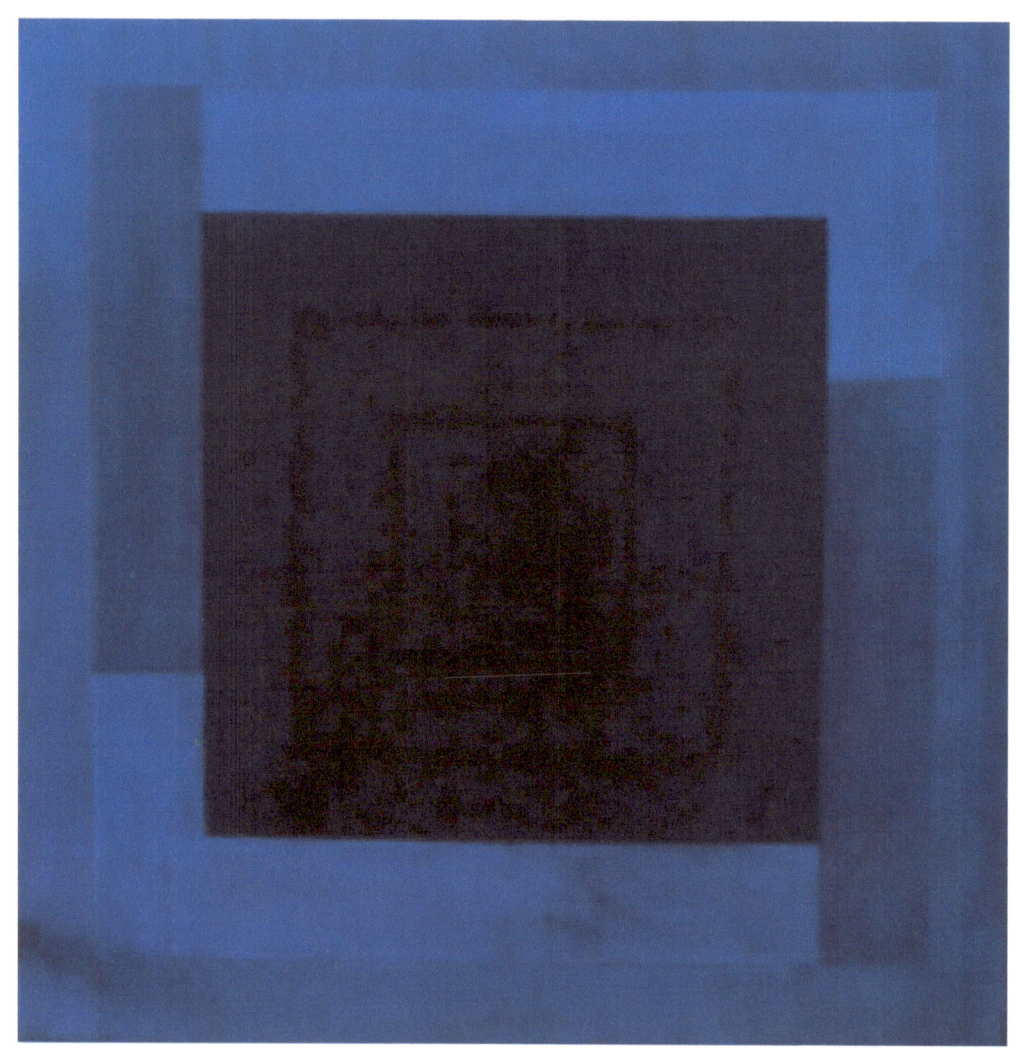

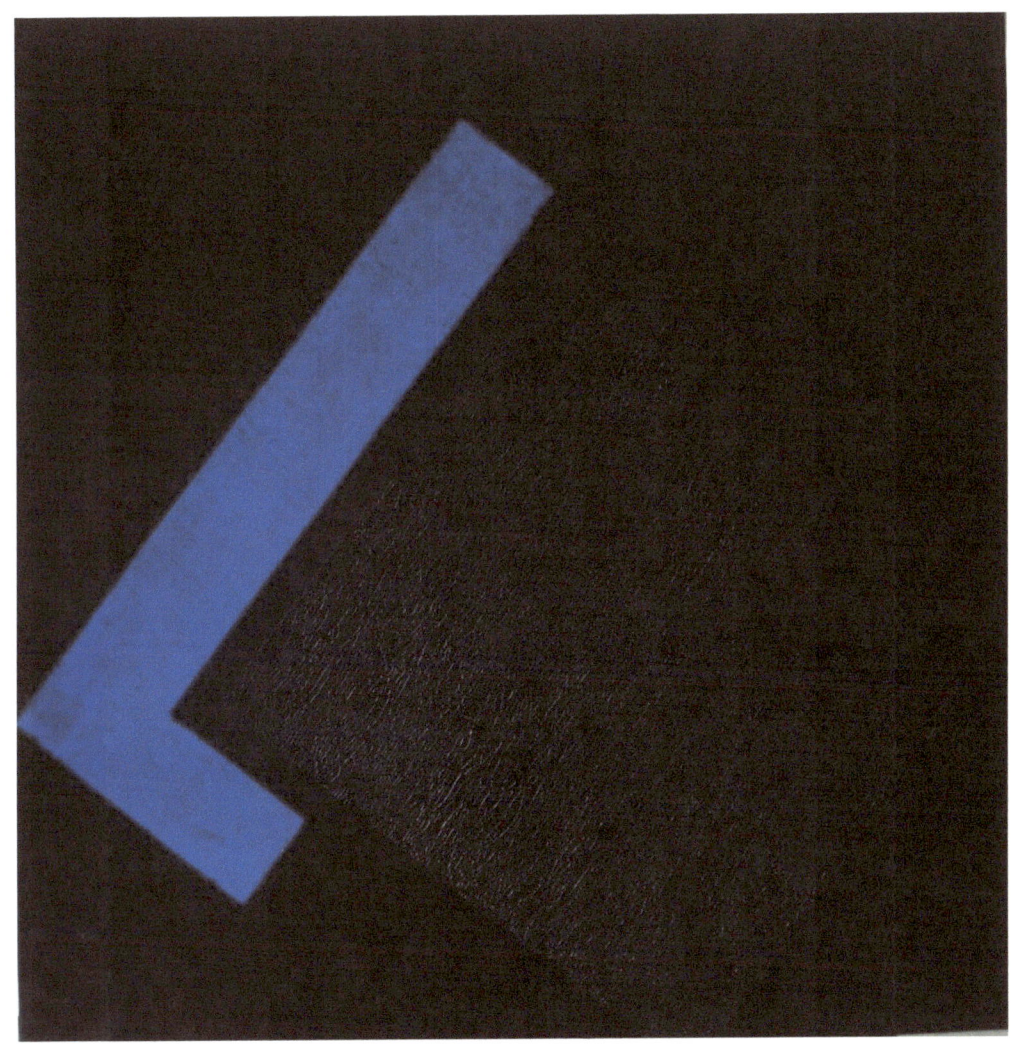

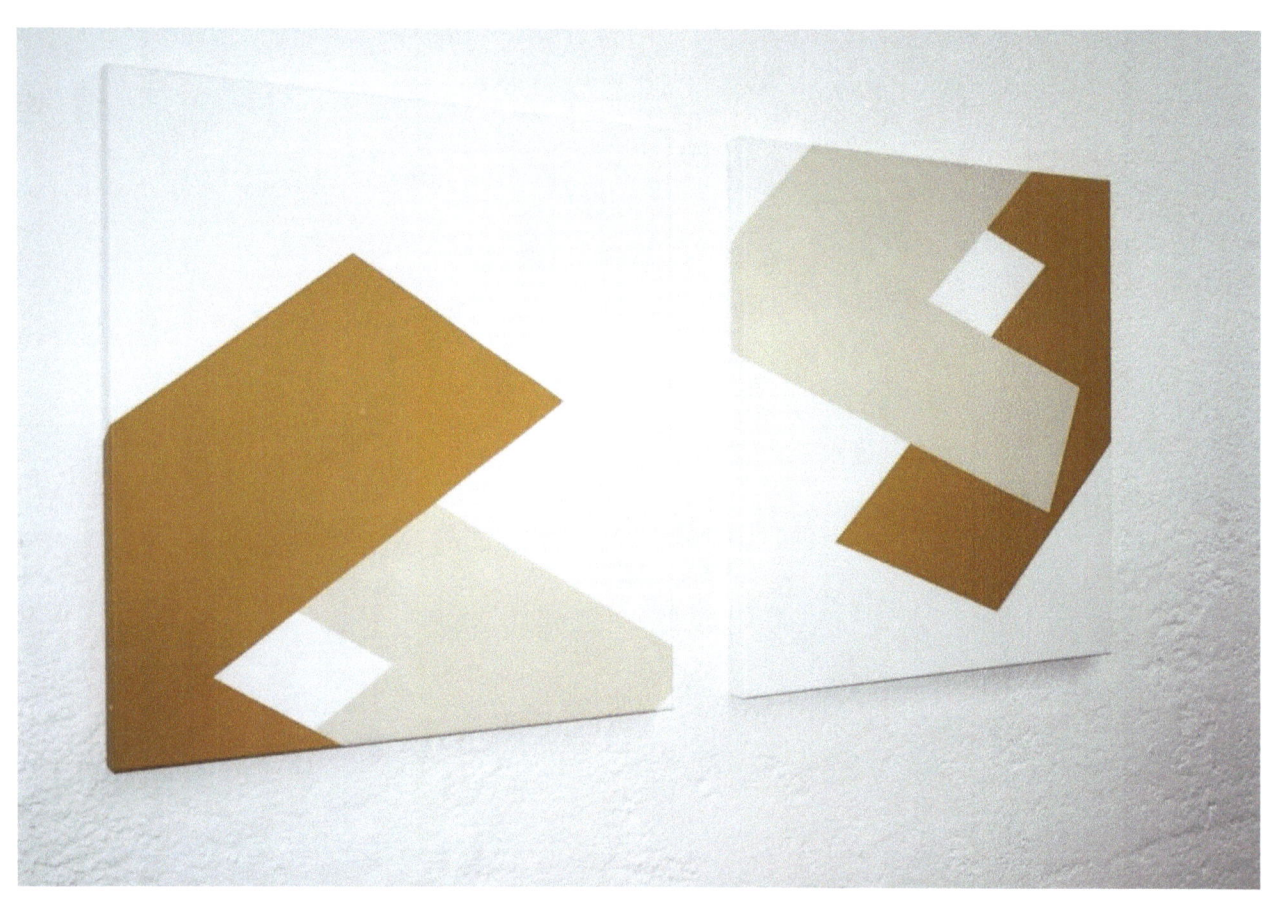

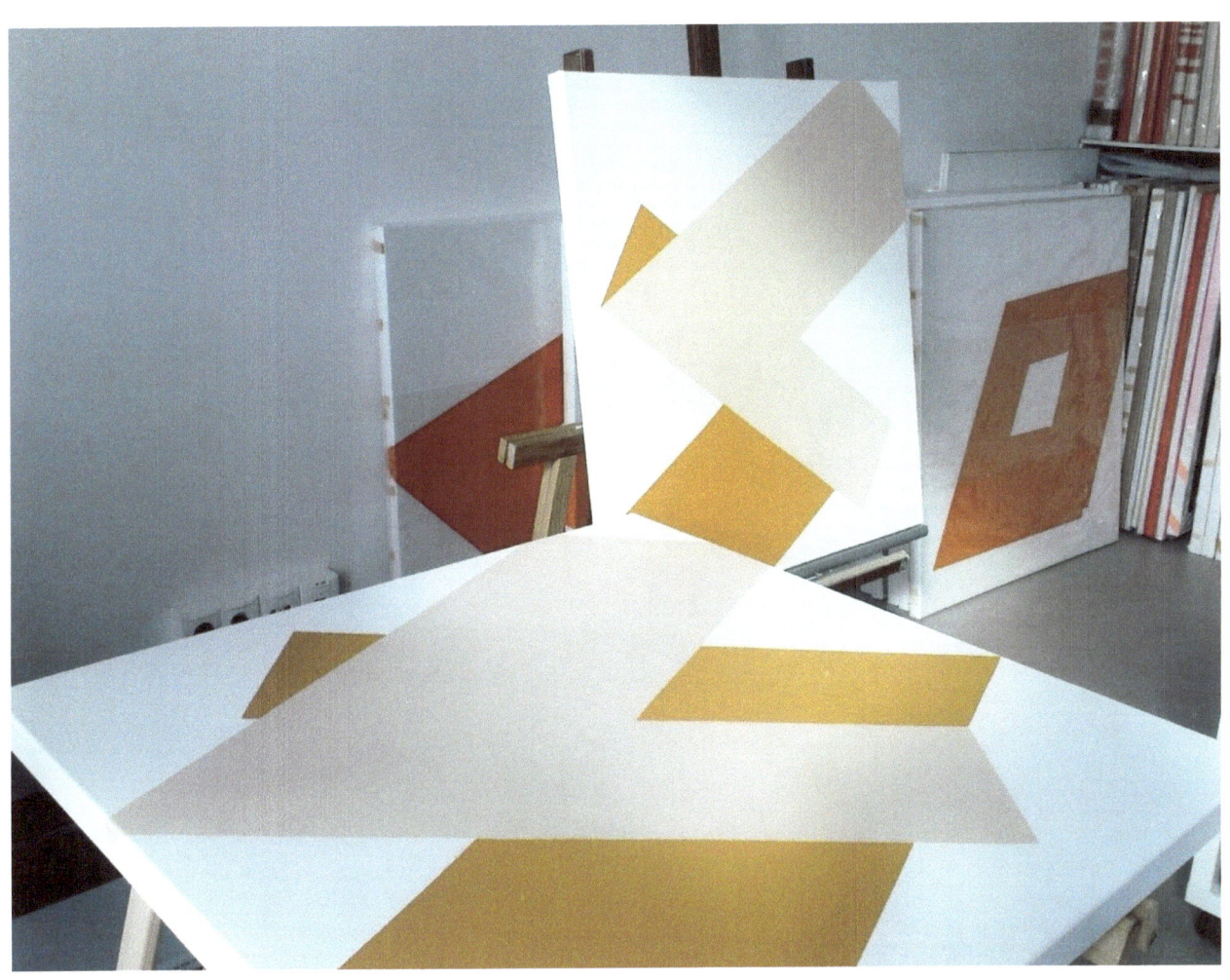

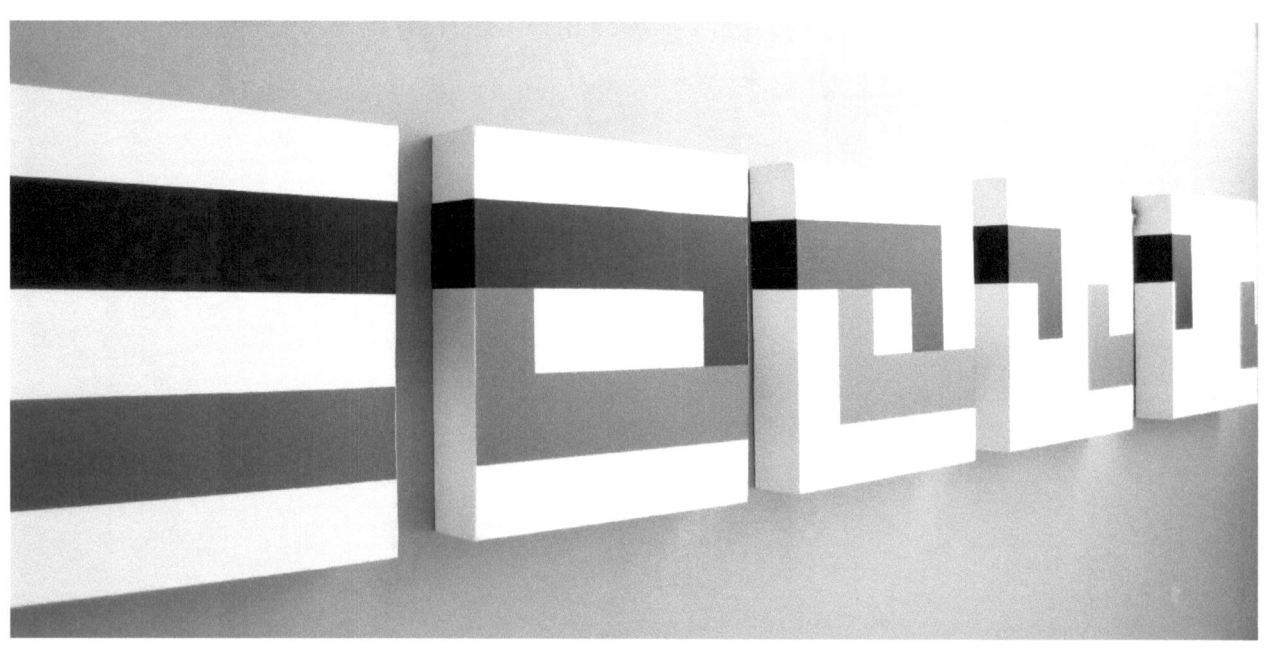

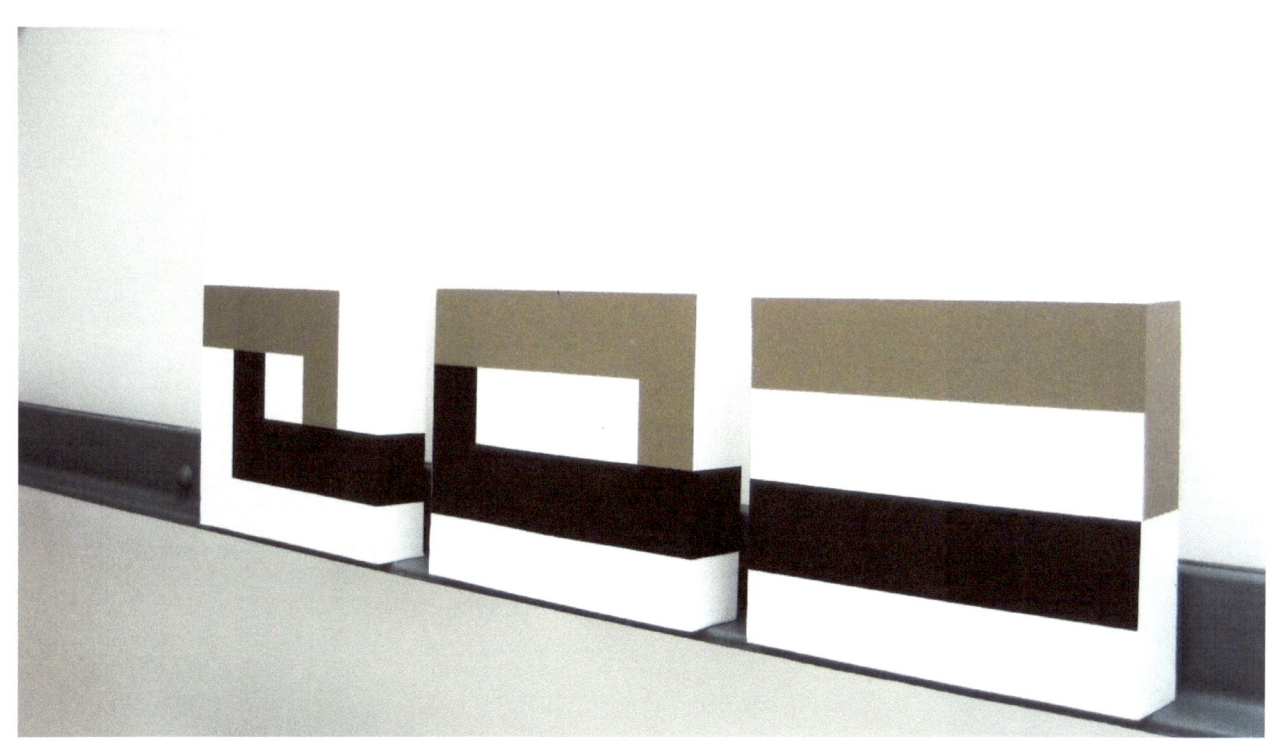

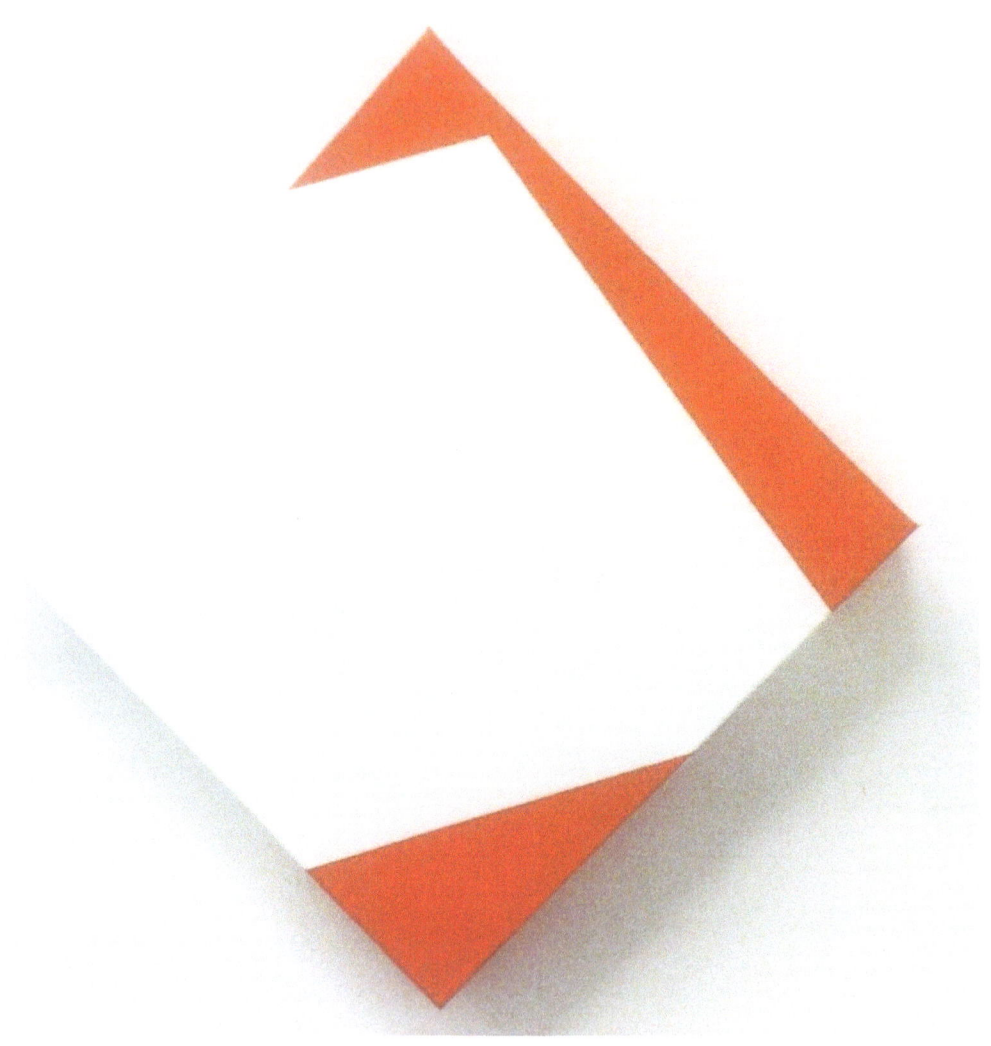

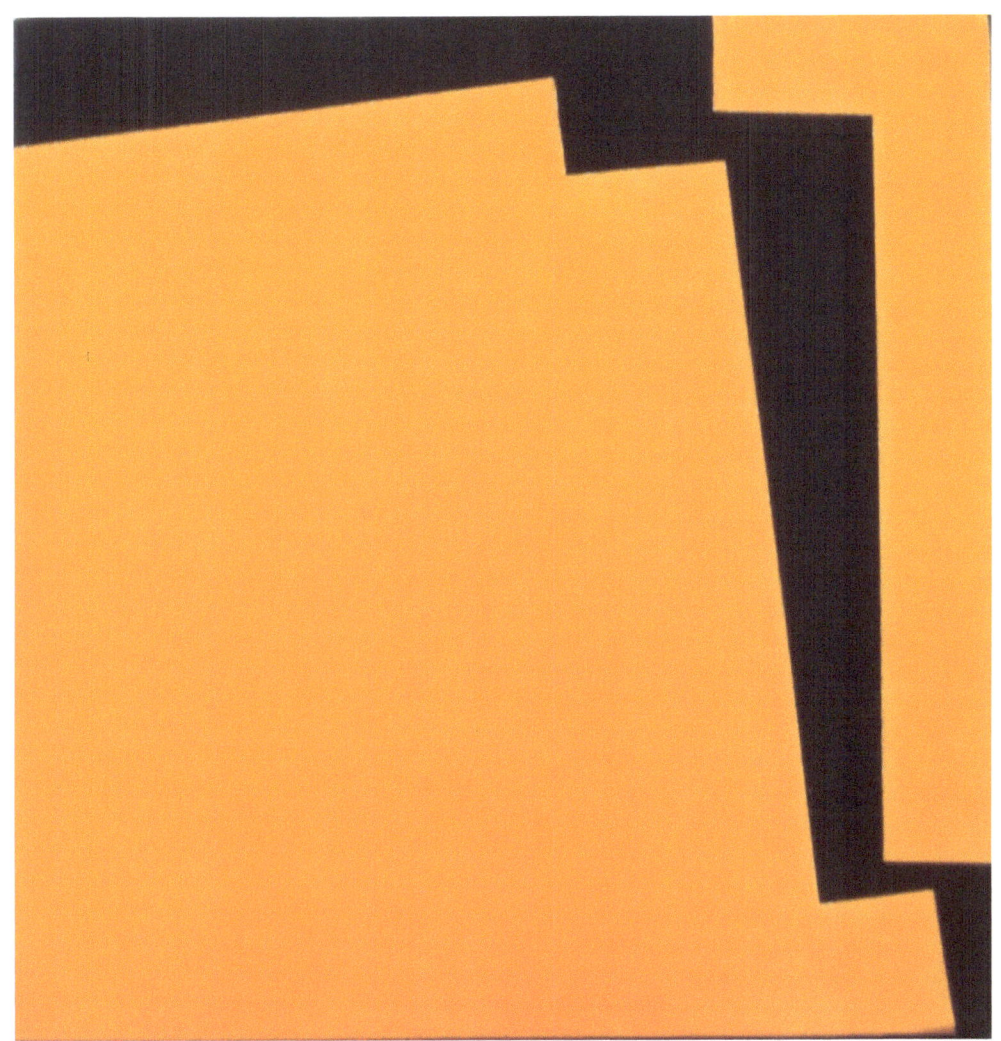

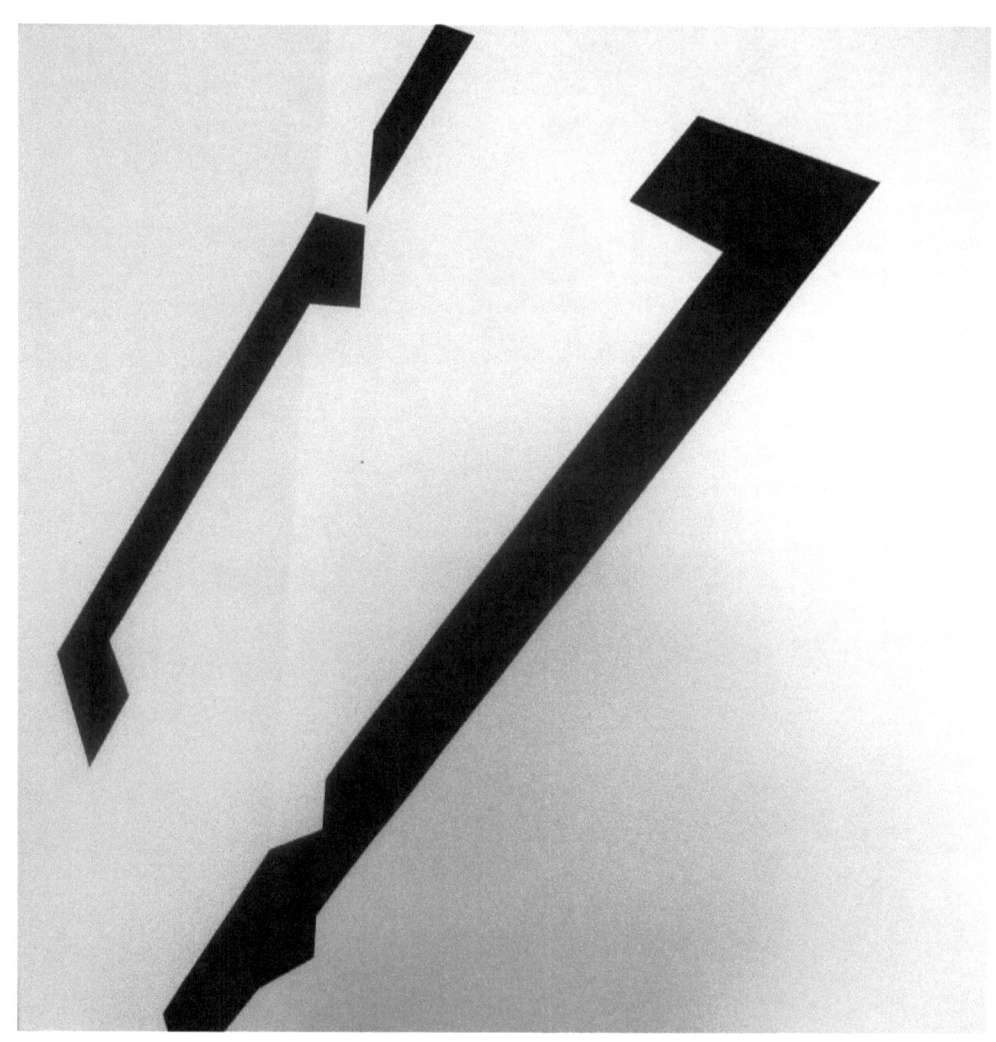

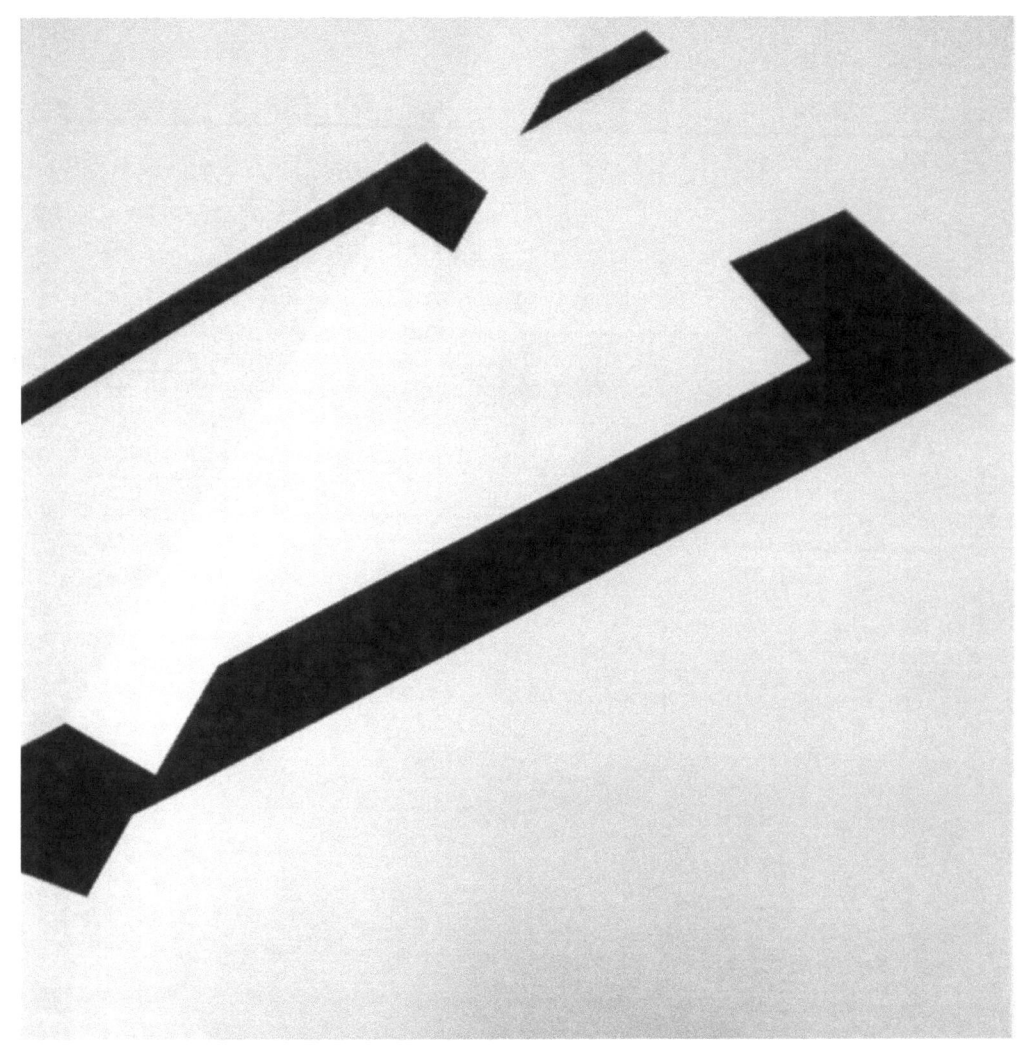

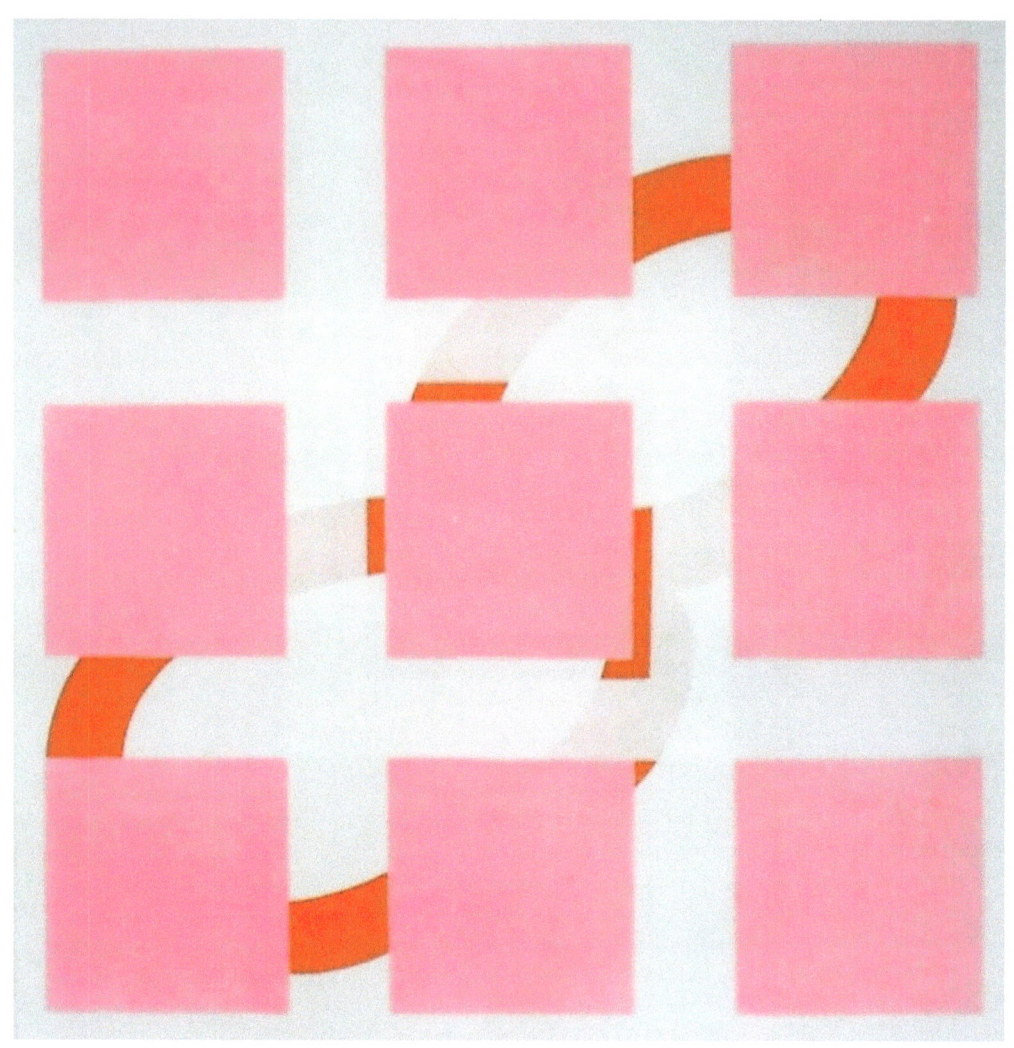

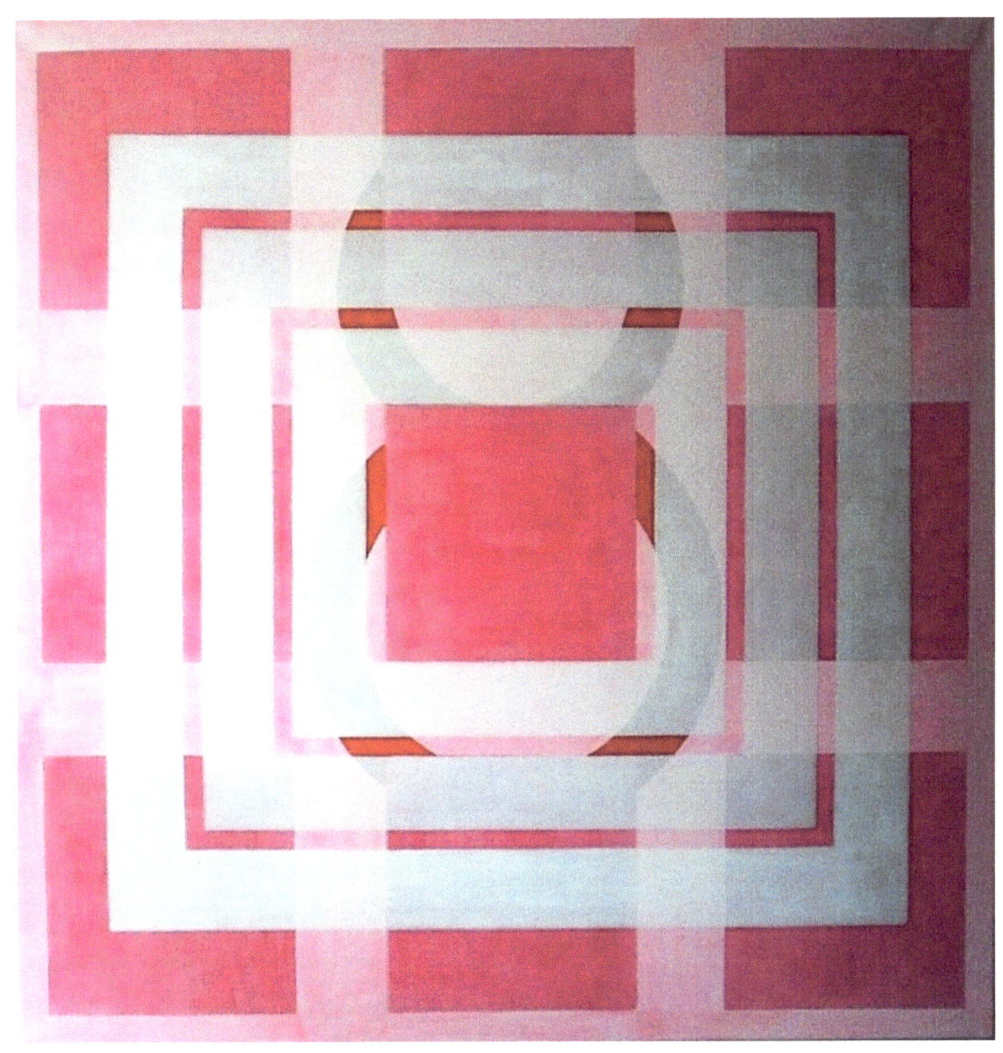

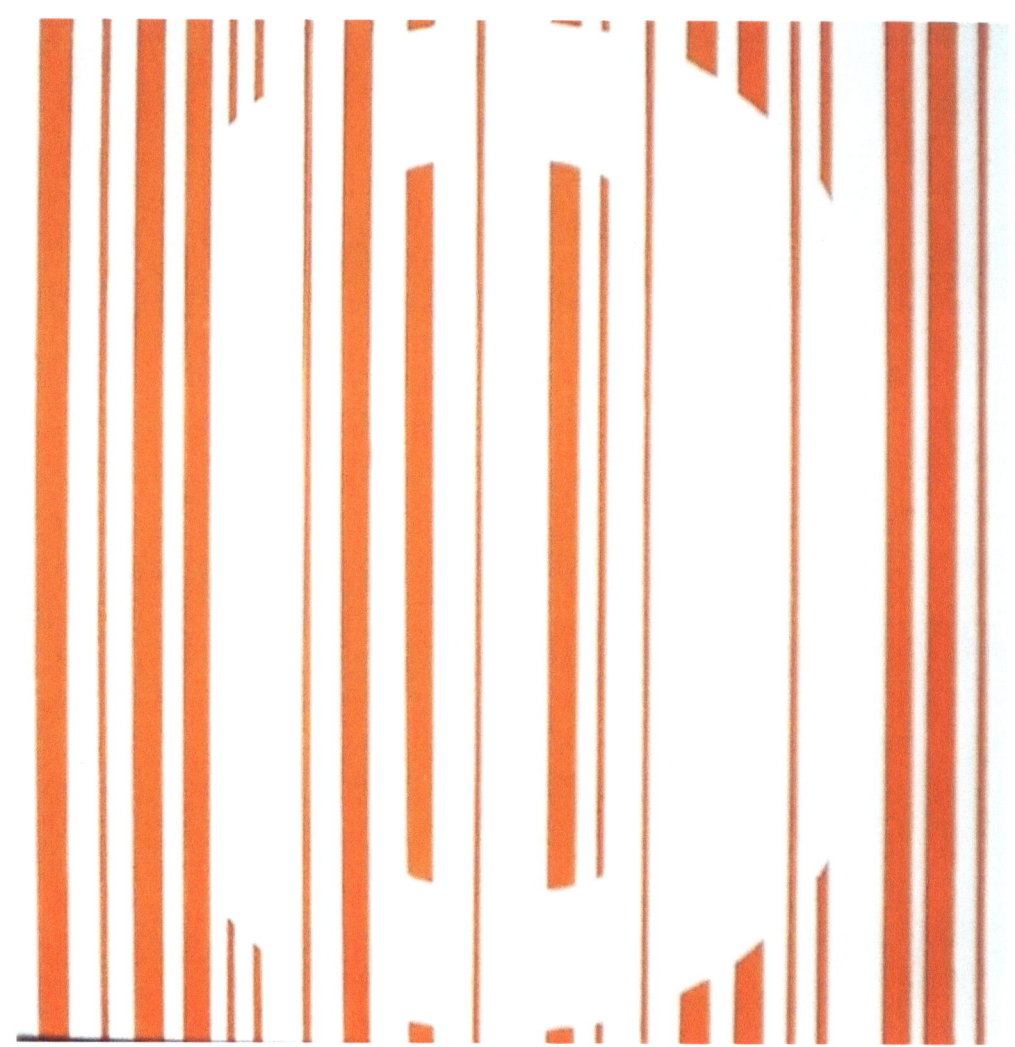

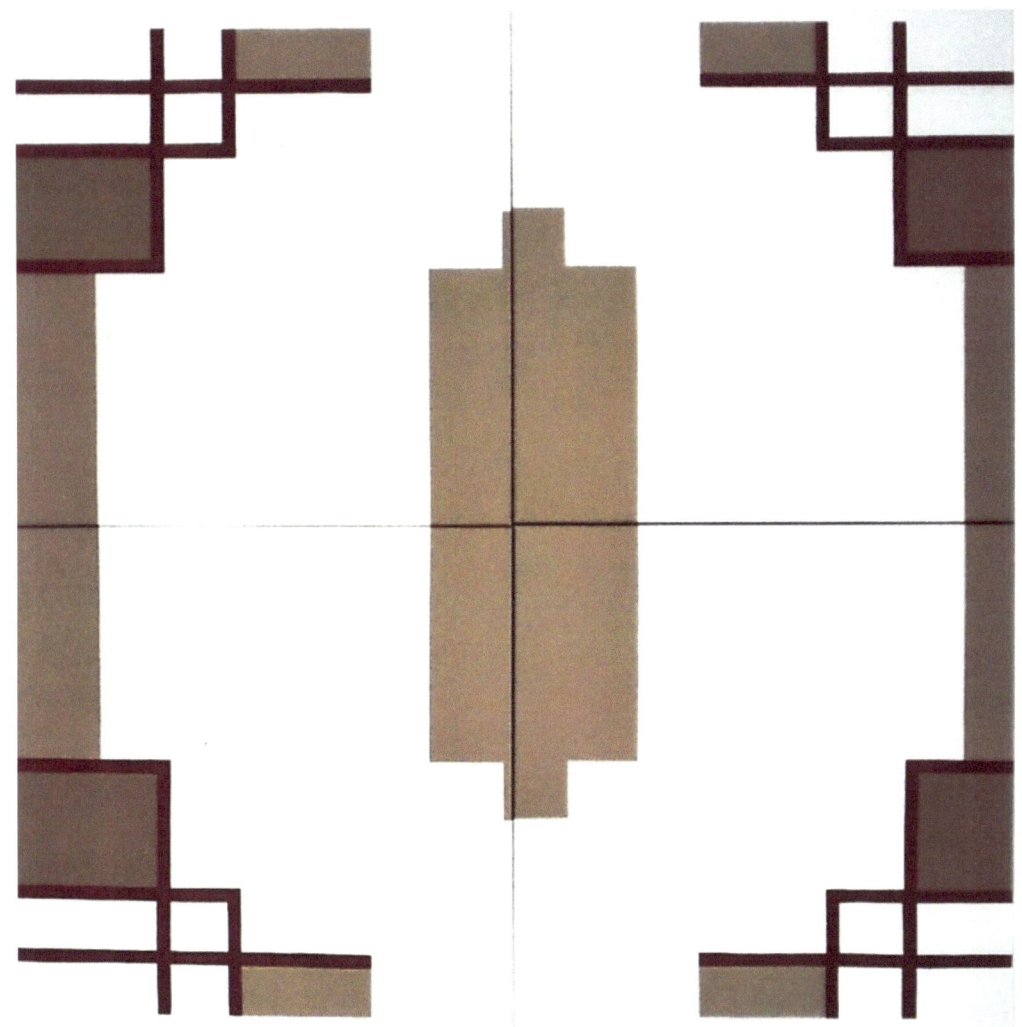

# ART OBJECTS
WOOD, GLASS, FELT
SINCE 2002

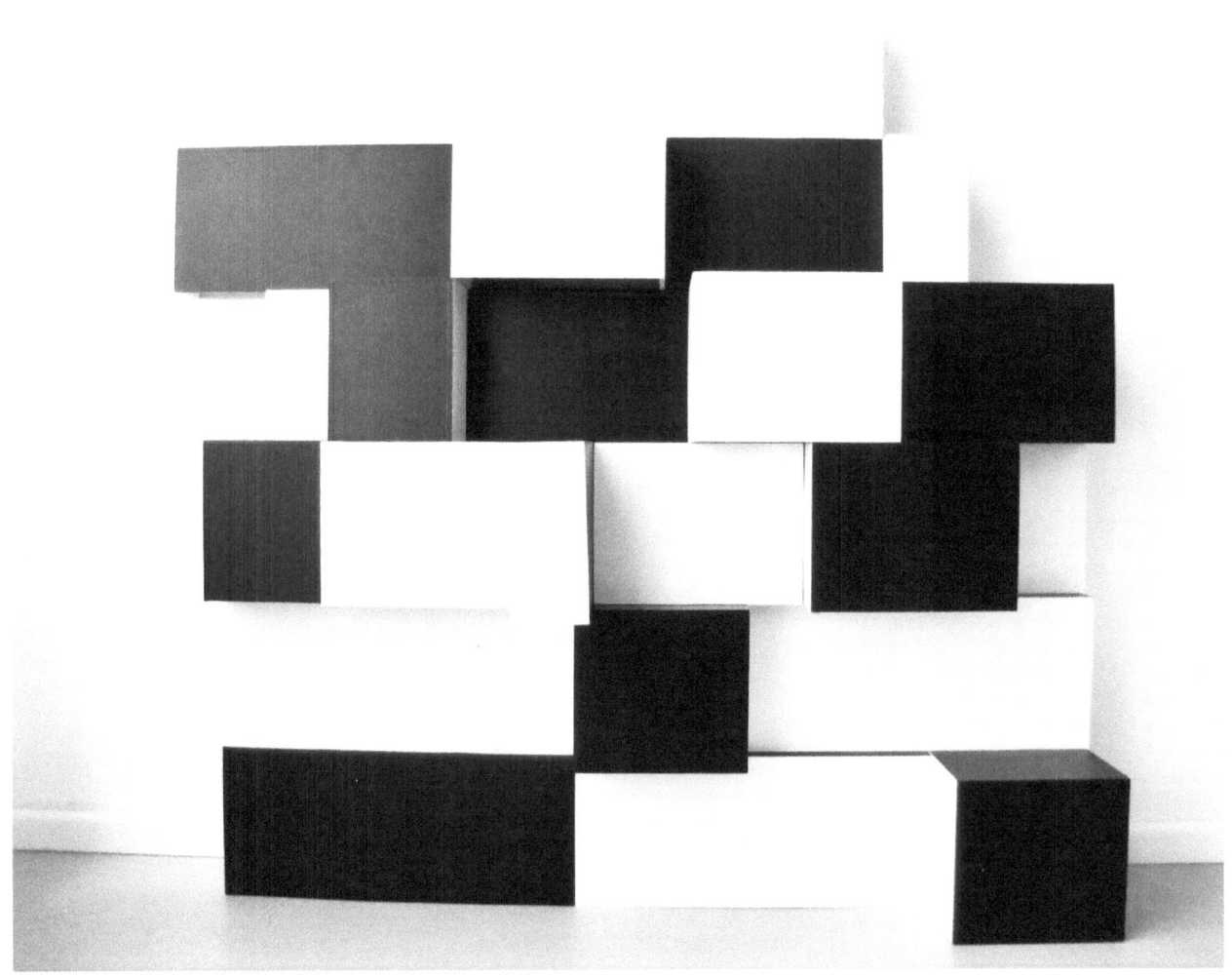

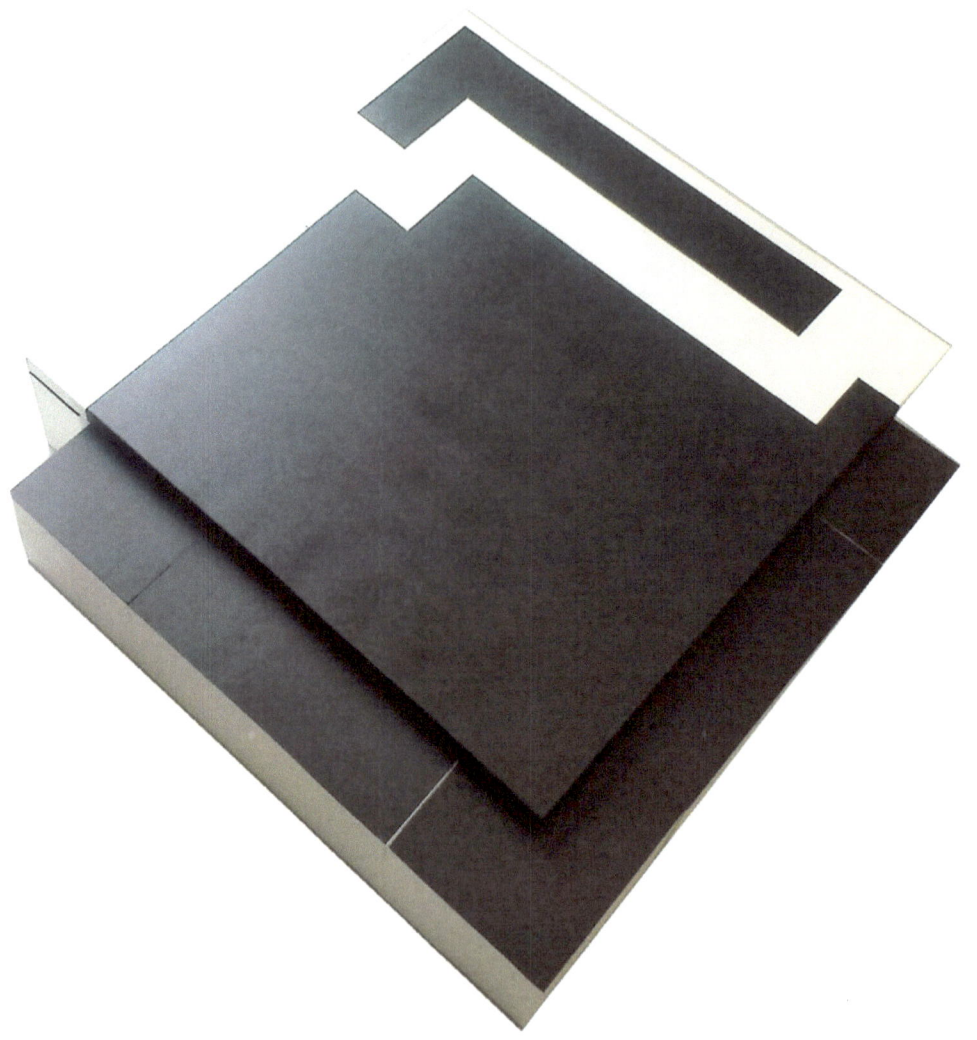

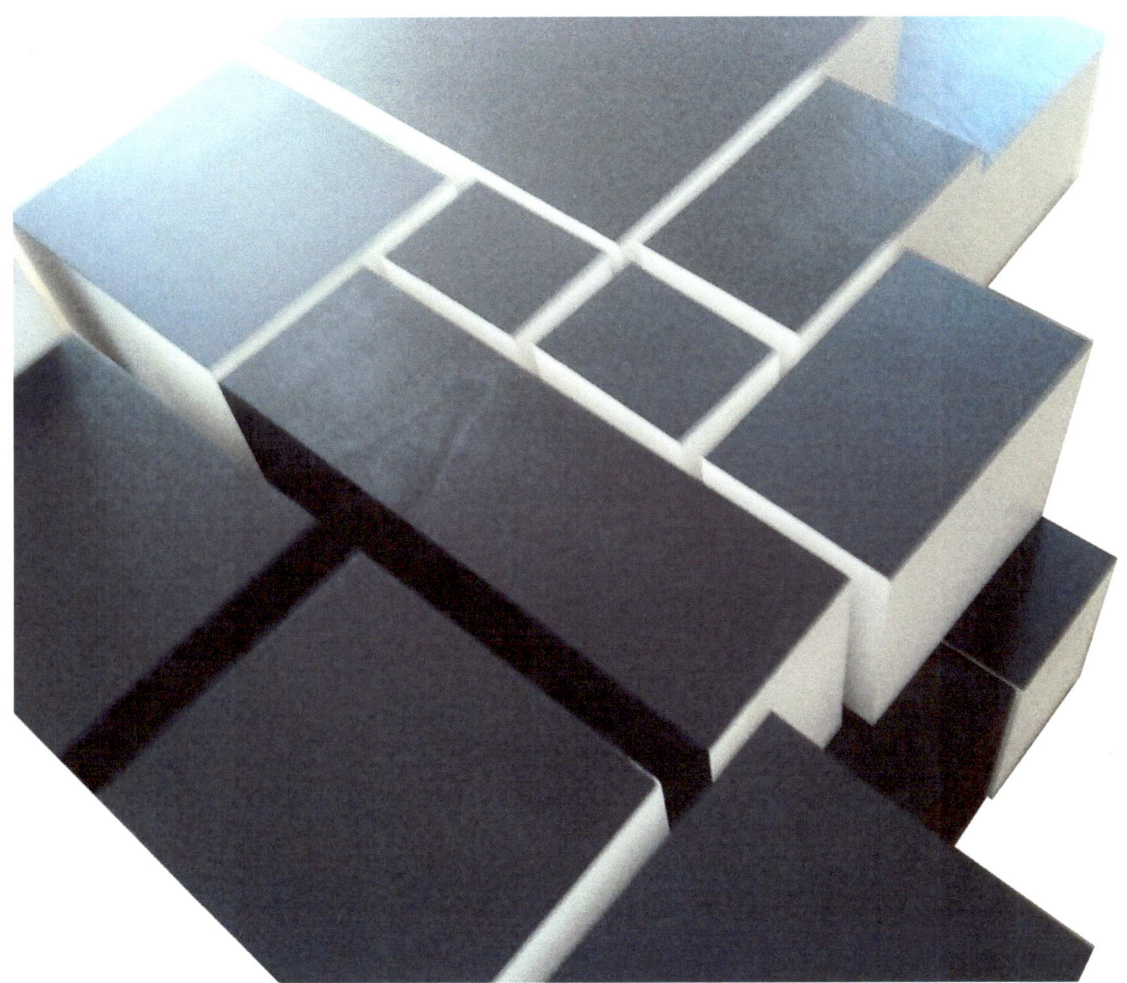

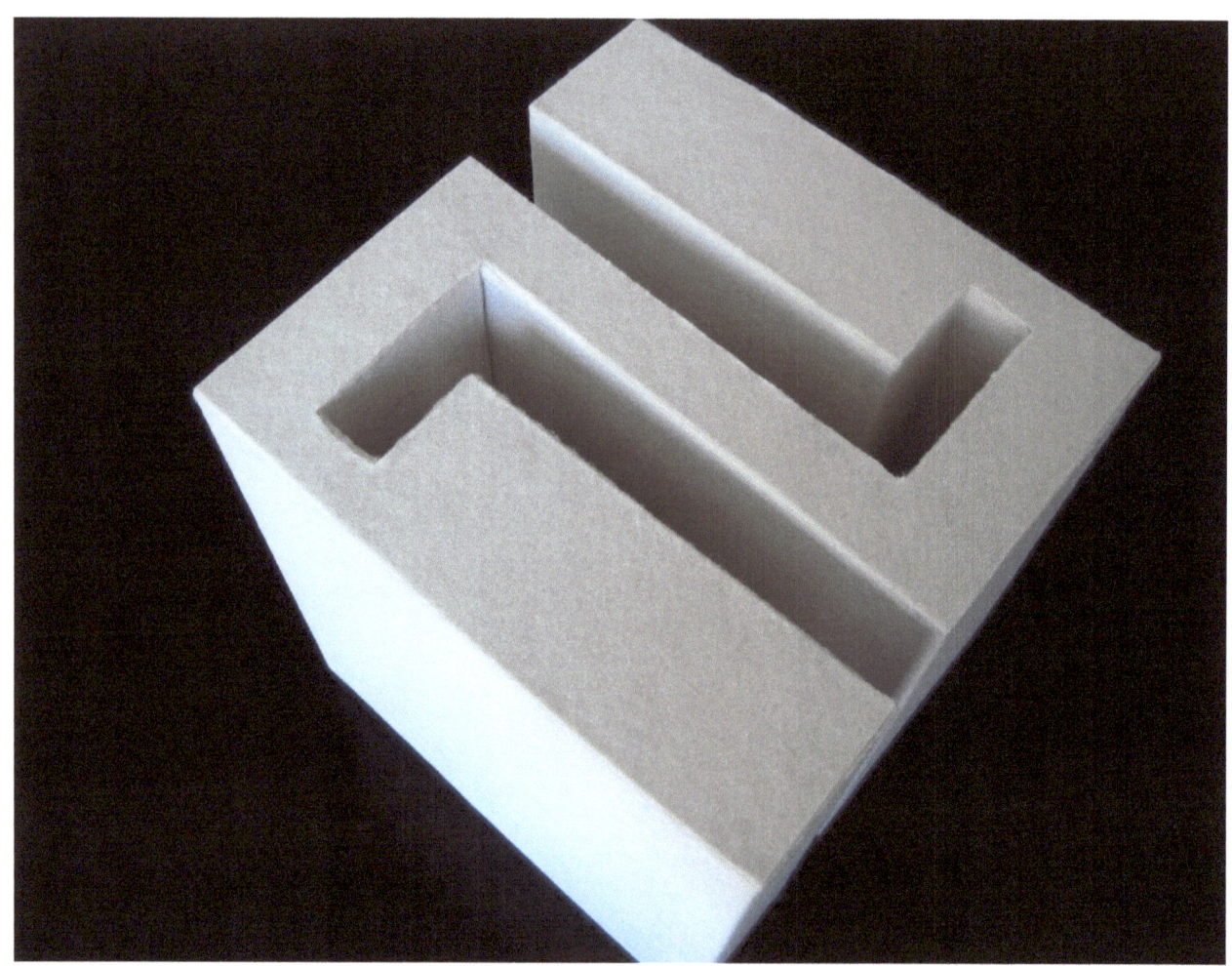

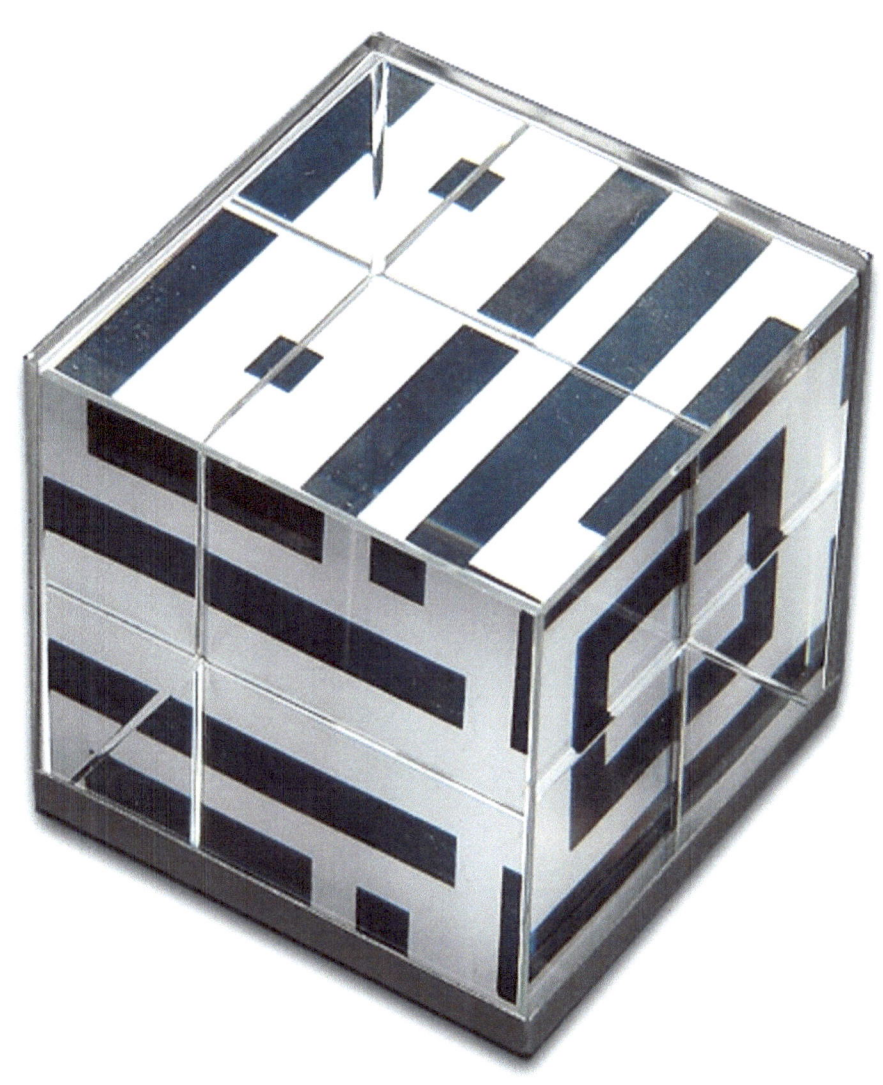

## VIDEO SOUND INSTALLATIONS
## SINCE 2007

The art videos act purely on the senses of the viewer.

They are generated by light, shapes, color and movement with a corresponding sound, presented as multiscreen installations or space-filling in audio-visual rooms.

The videos are designed to play nonstop as a loop. The size and scope is variable.

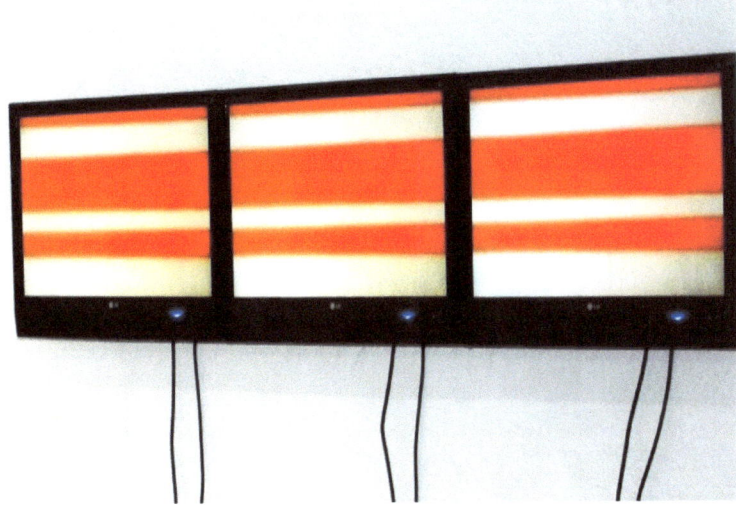

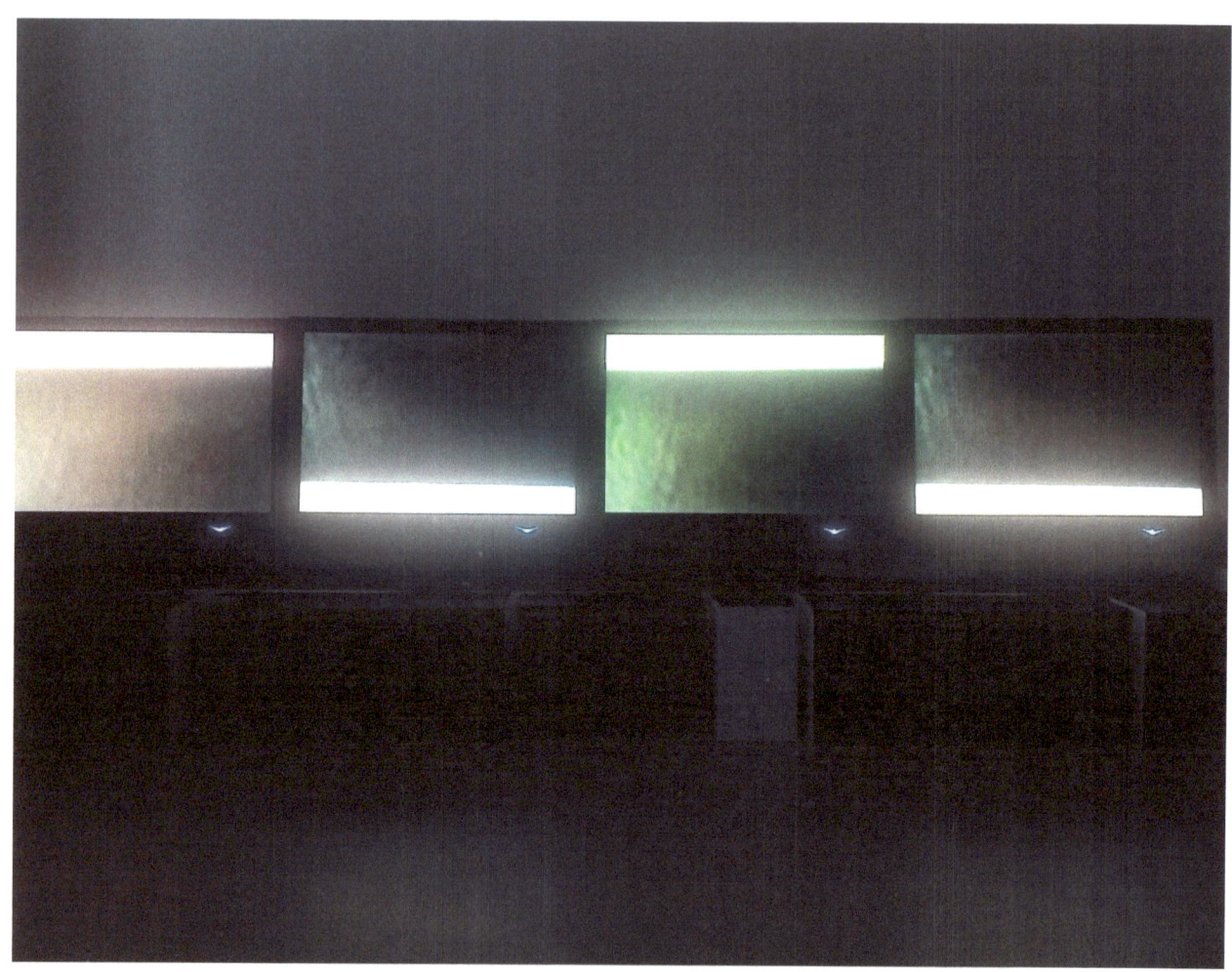

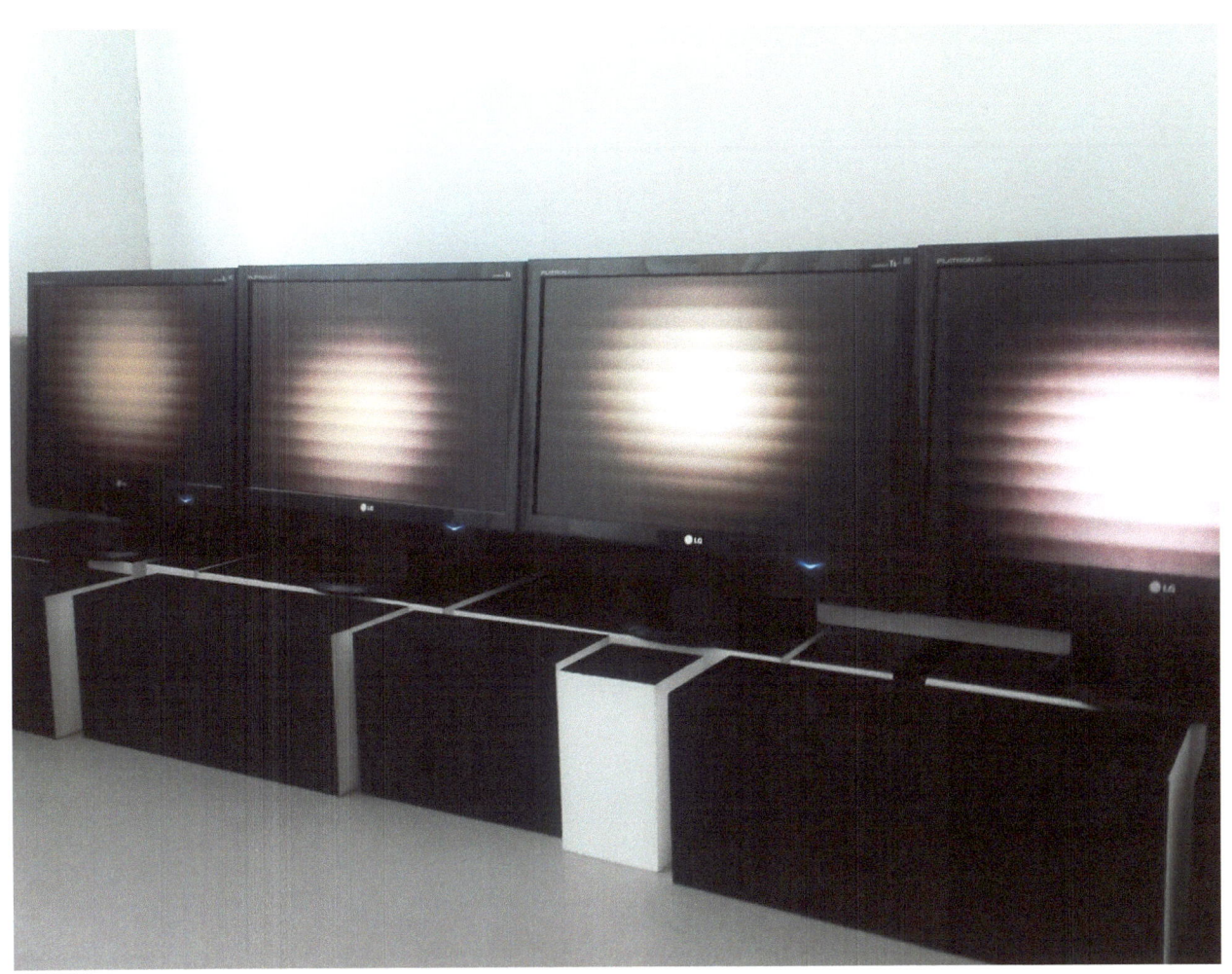

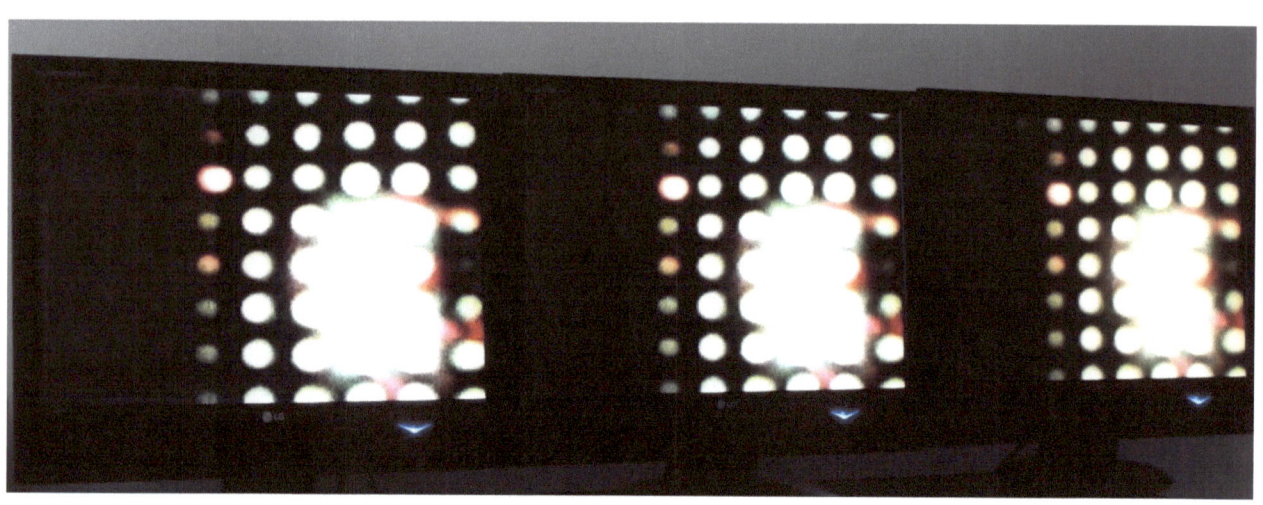

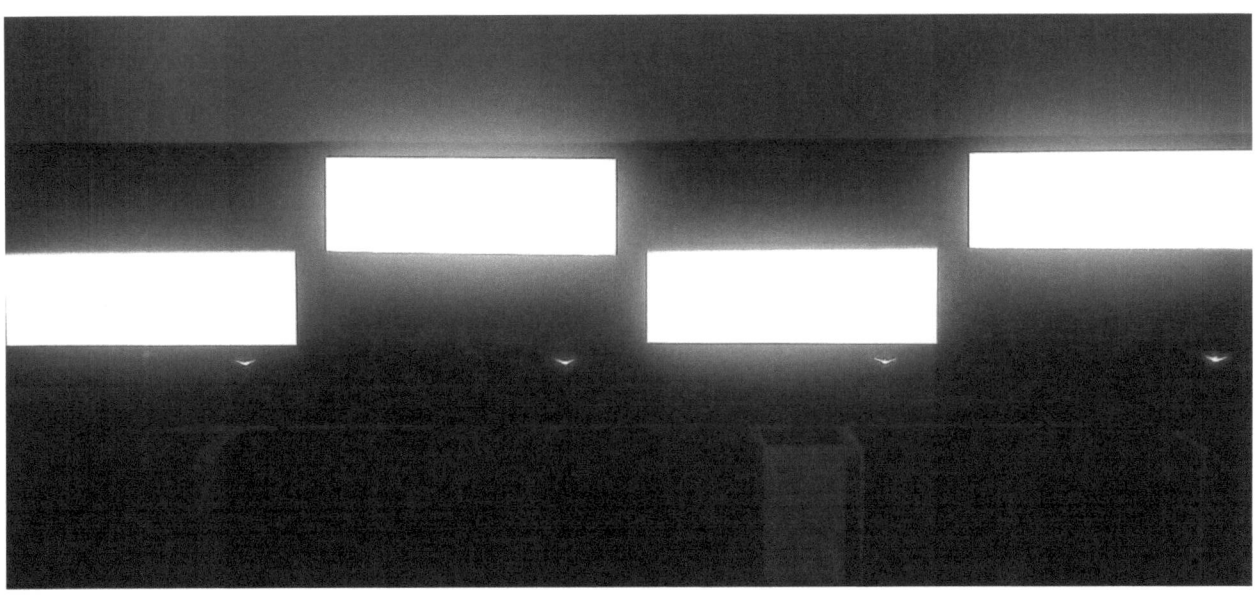

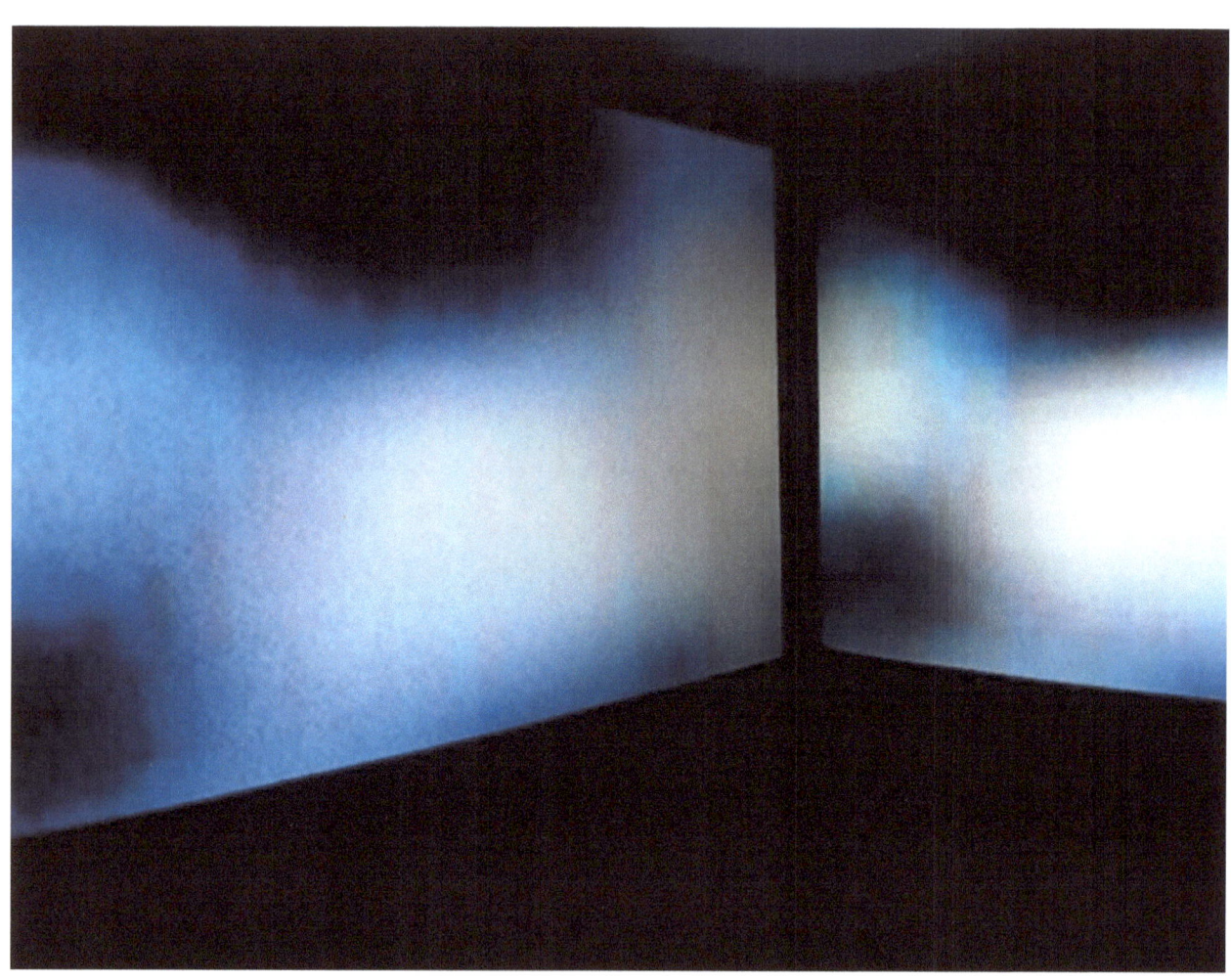

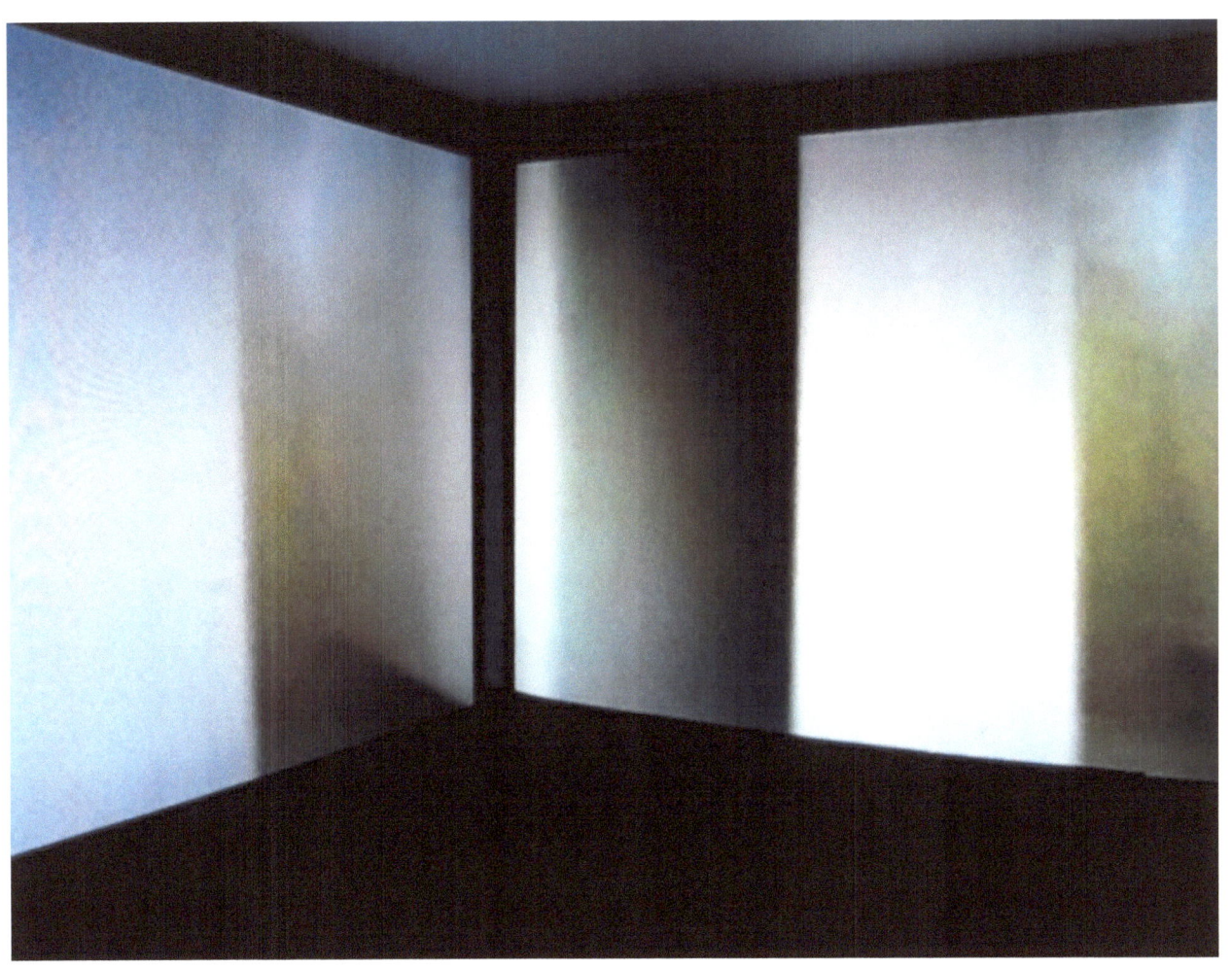

PHOTOGRAPHY – EXPERIMENTAL – LIGHT-GENERATED AND COMPUTER-PROCESSED
SINCE 2009

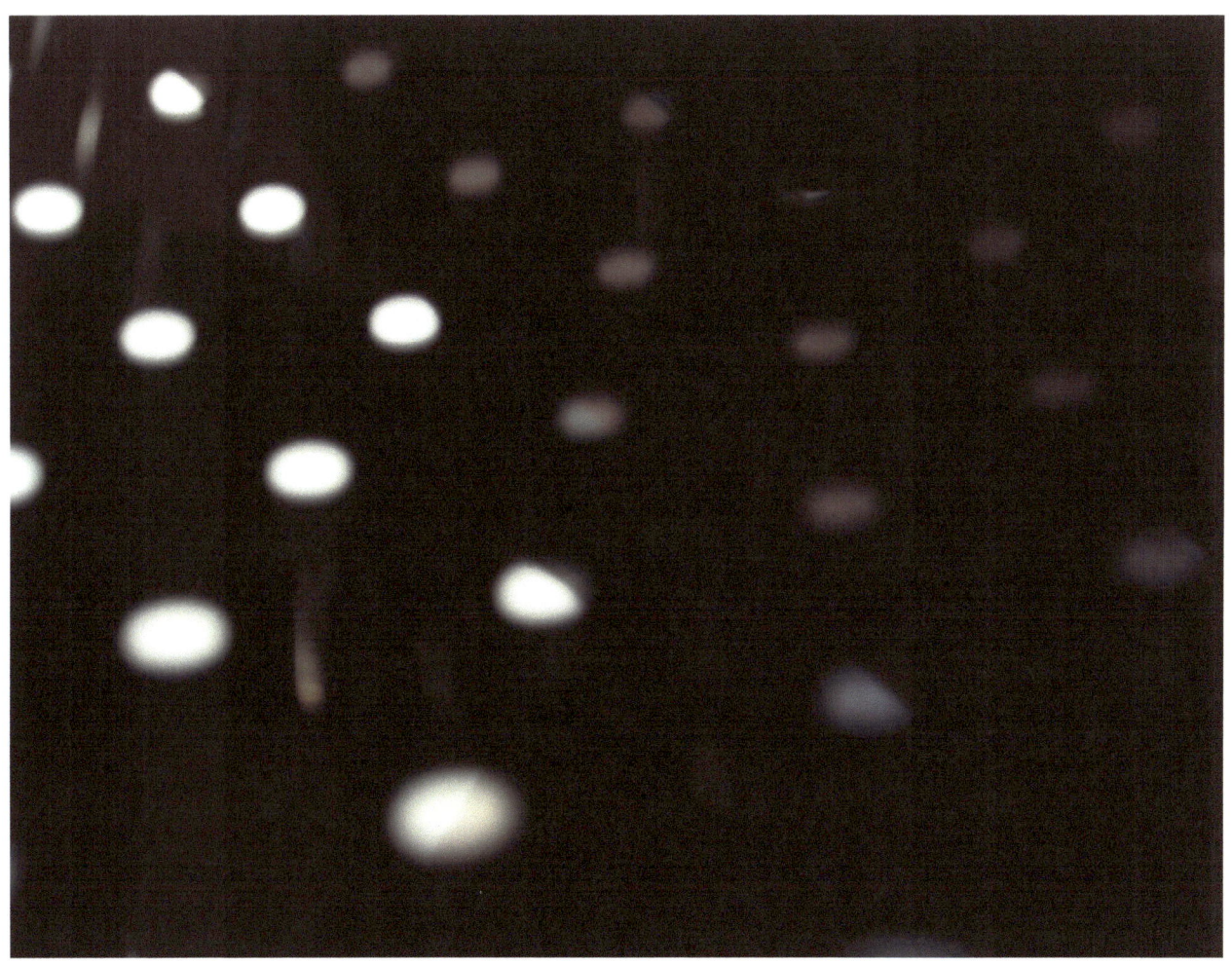

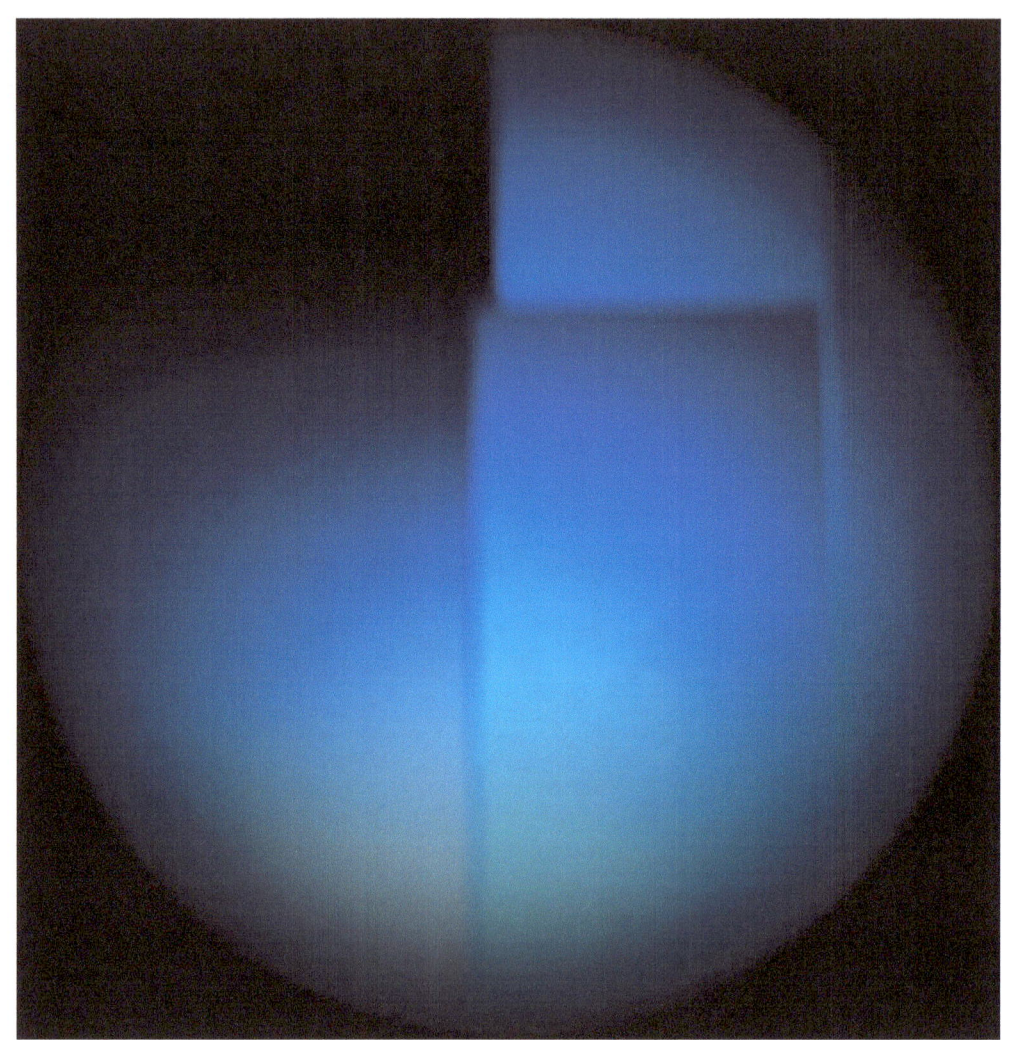

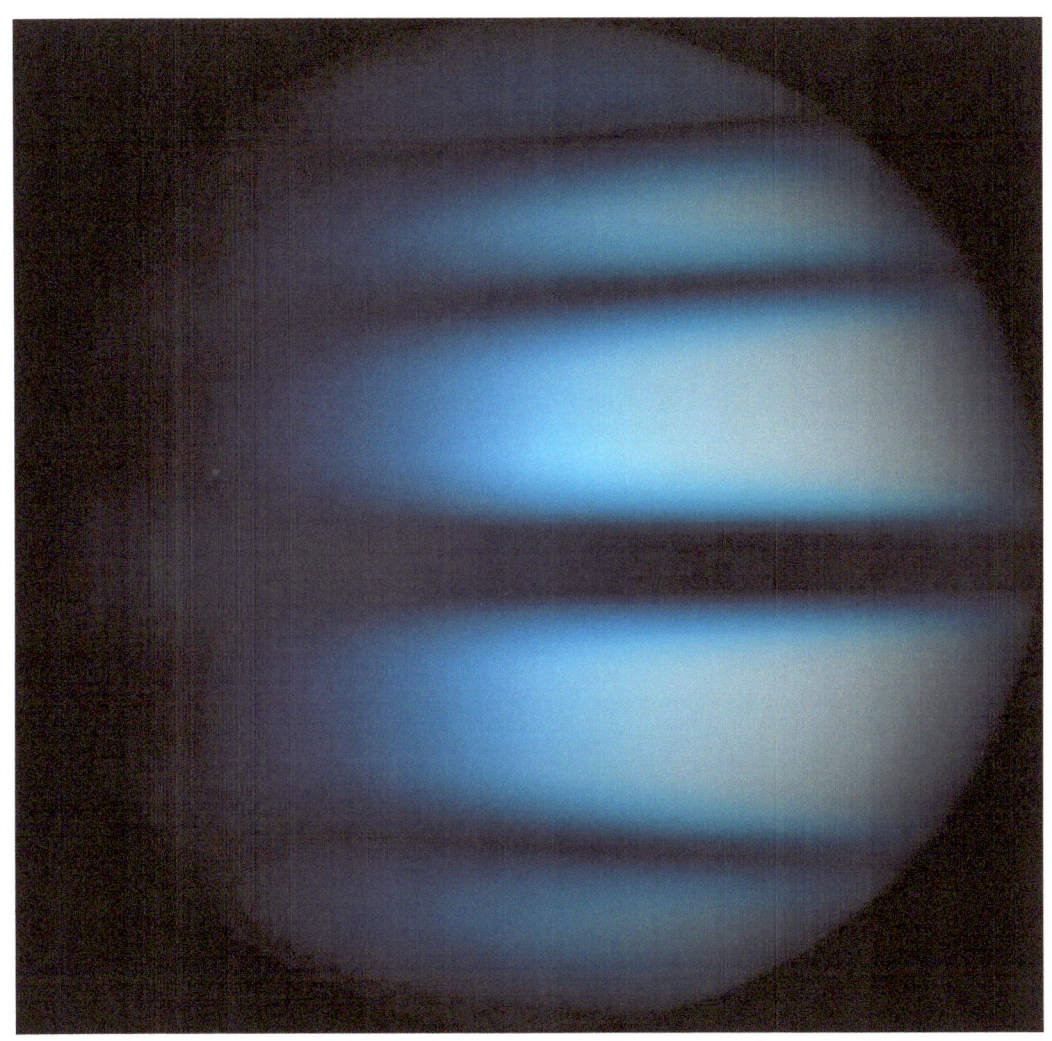

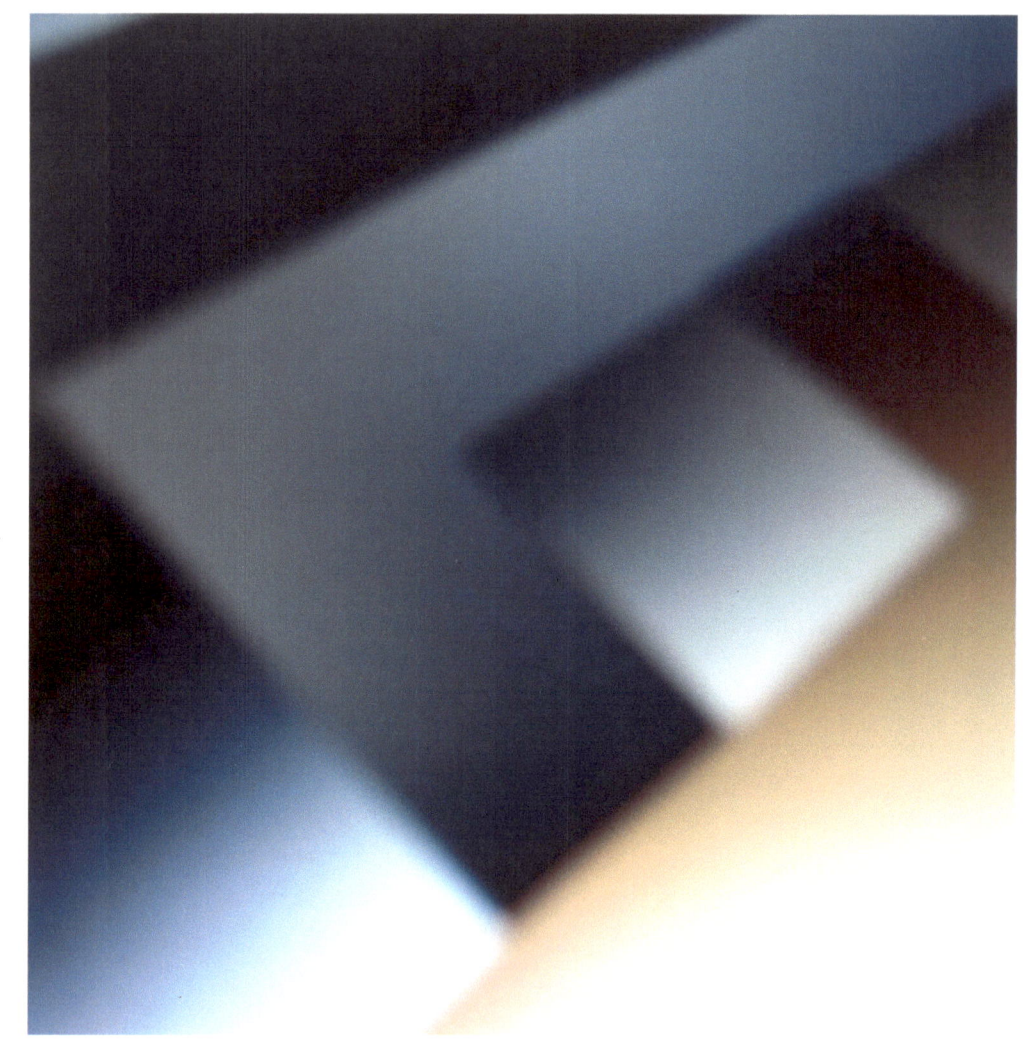

# PRINT EDITIONS - COMPUTER-CREATED
SINCE 2009

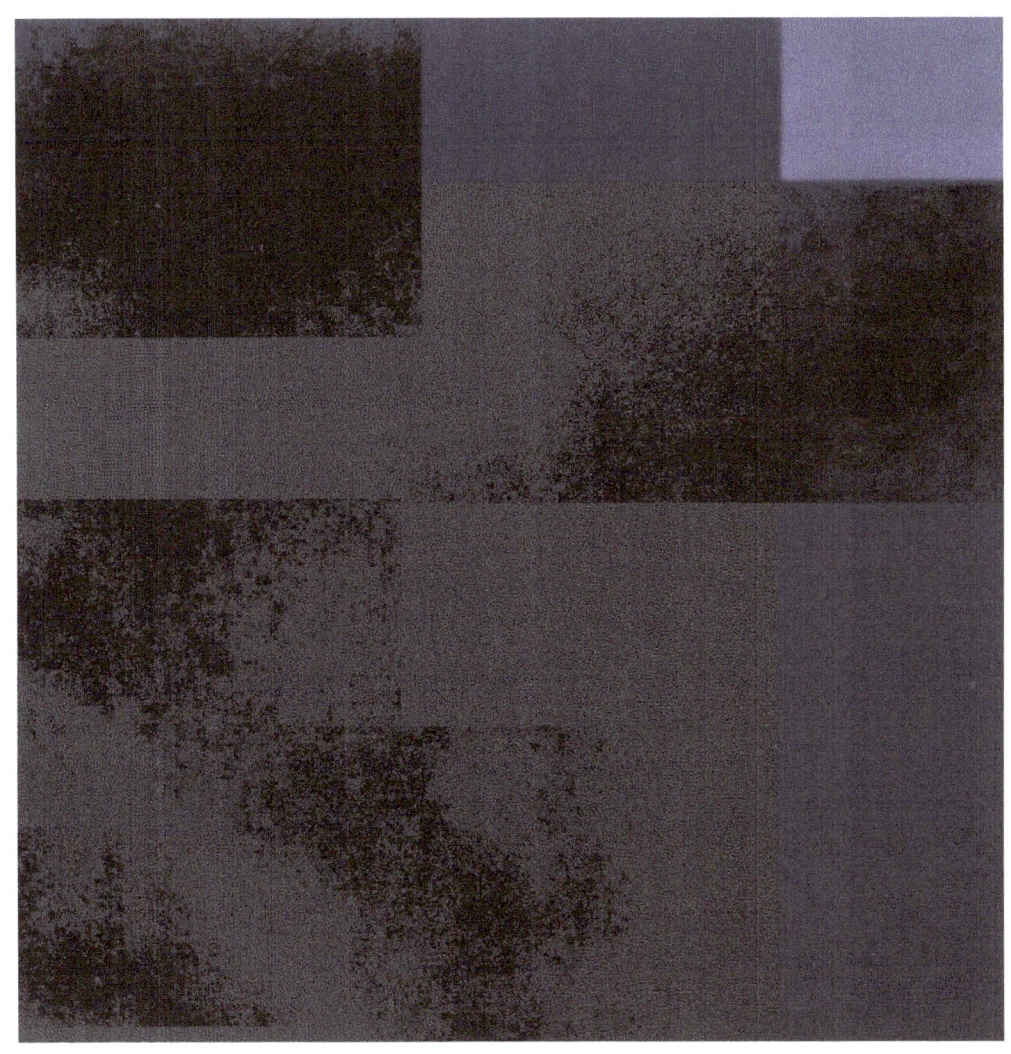

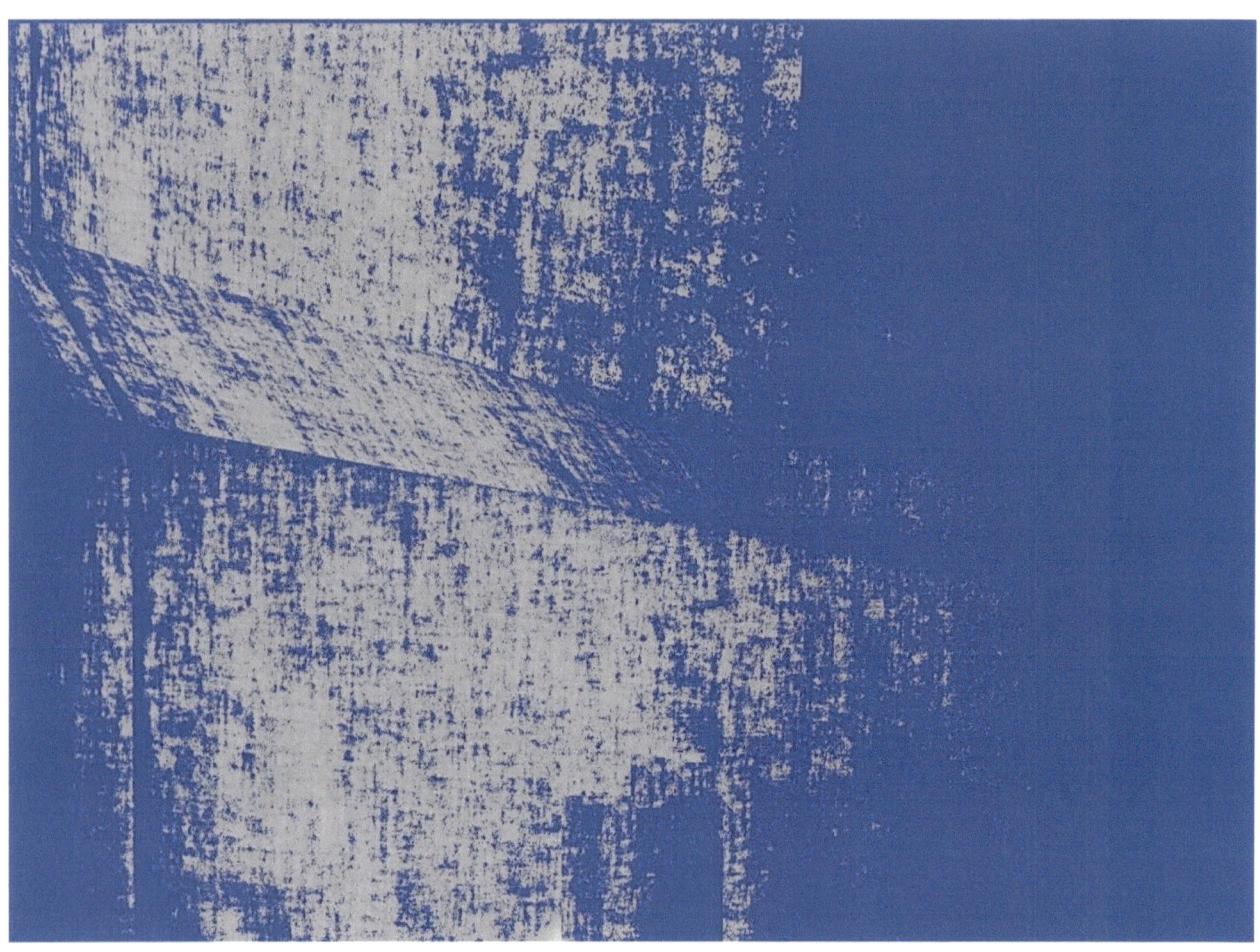

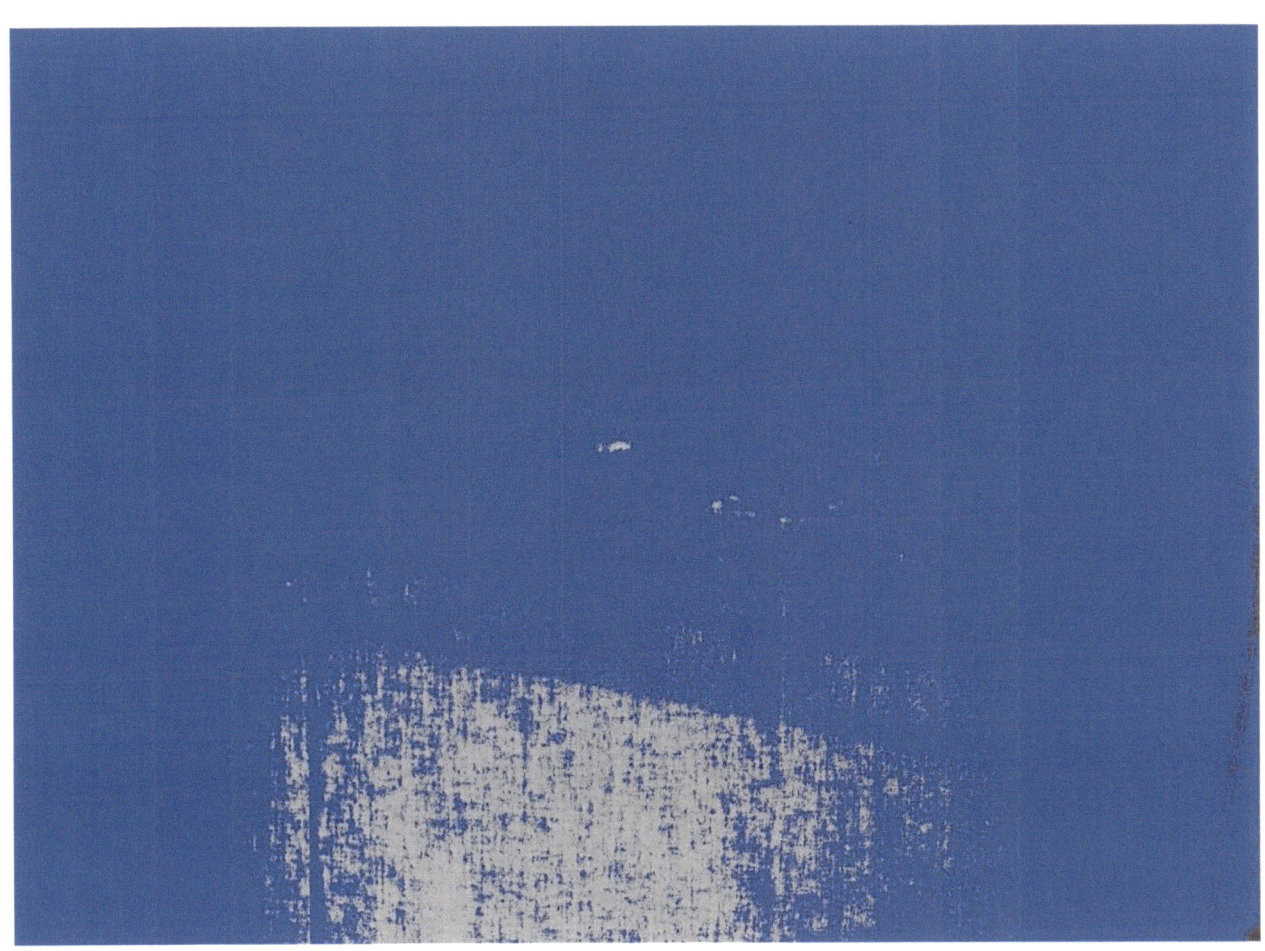

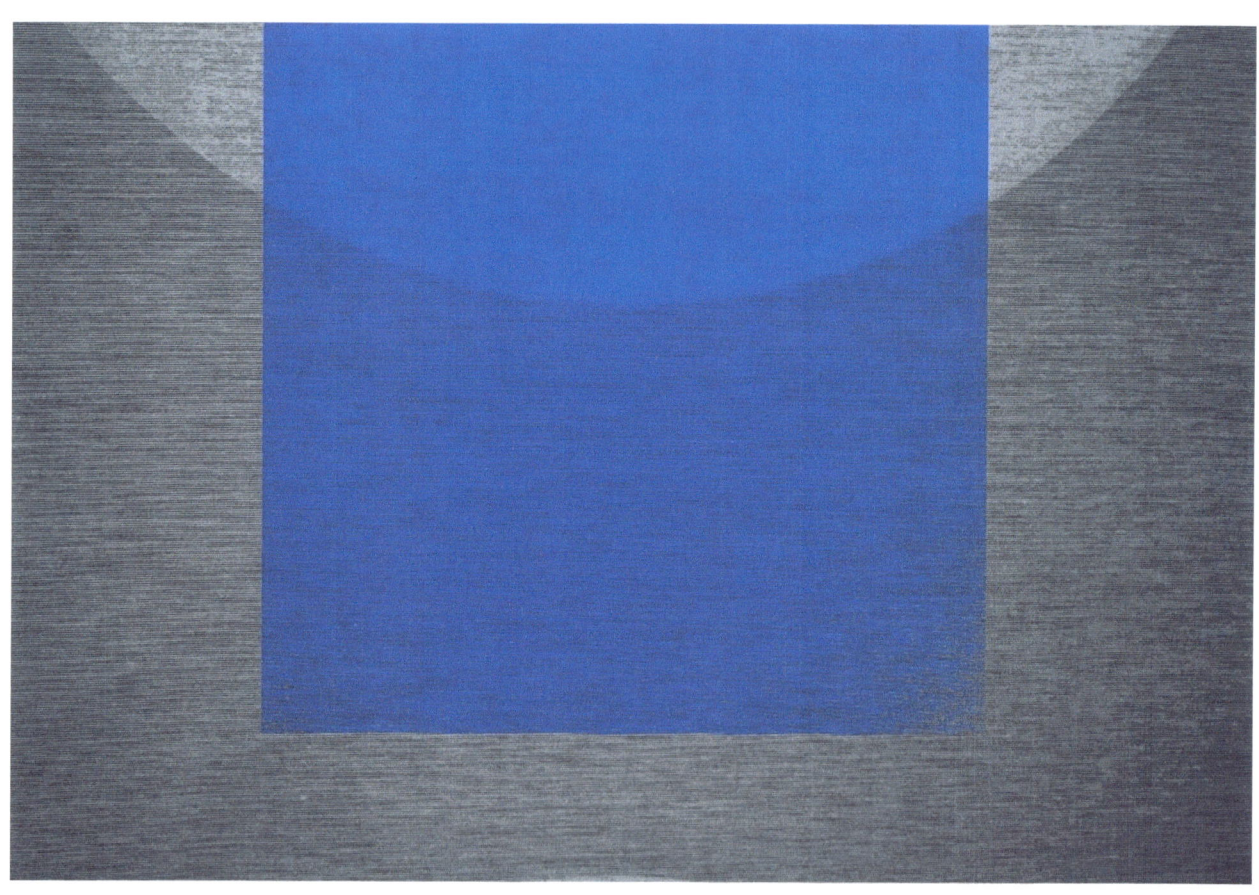

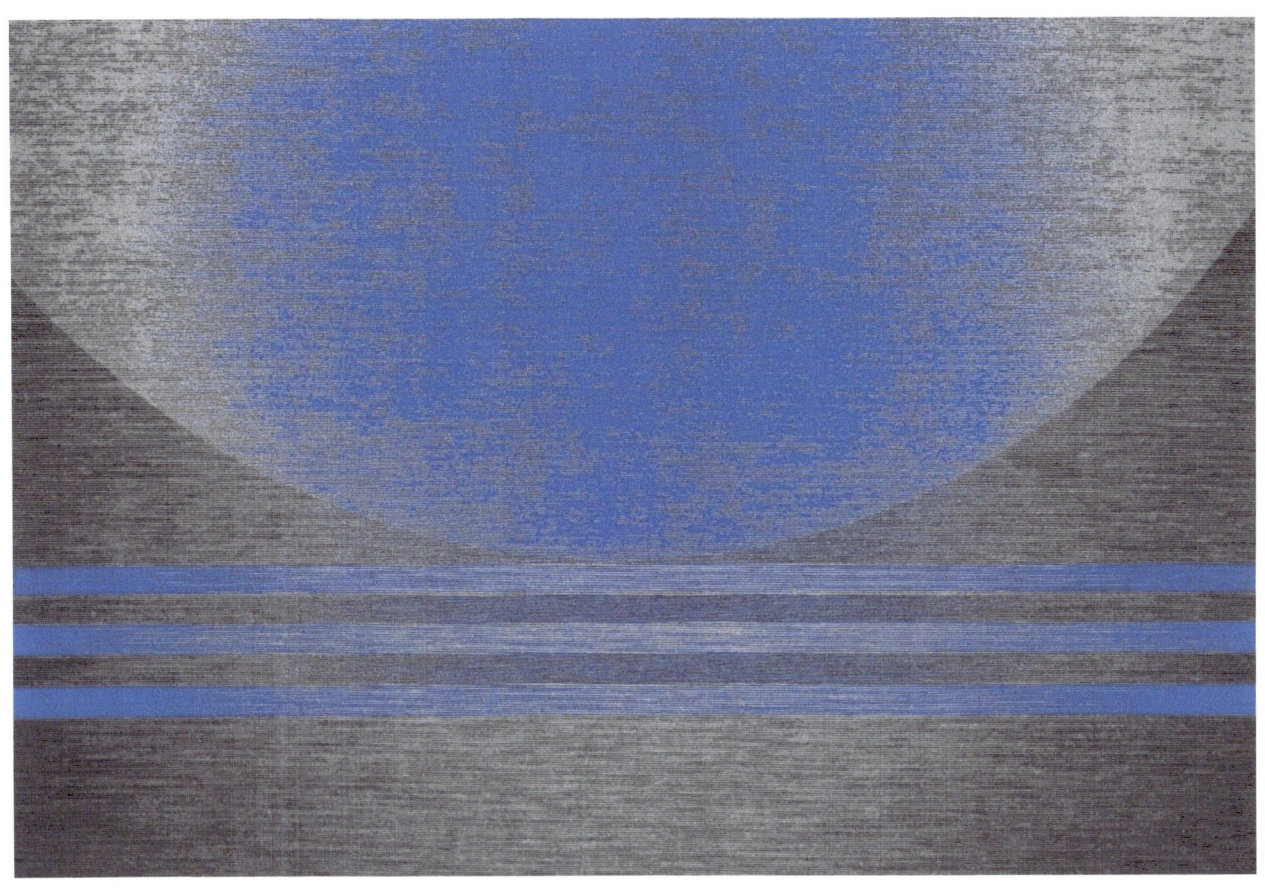

ABOUT THE ARTIST

THERE IS ALWAYS SOMETHING NEW TO DISCOVER

Eva Bauer
was born in Braunschweig, Germany.

She studied art in Germany at the Fachhochschule in Trier
and then at the Hochschule der Kuenste in Berlin.

Eva Bauer first worked figuratively, creating life-sized figures made of wood when she lived in Ibiza, Spain for 12 years. After her return to Germany, she began working in the style of Concrete Art in 2002.

During the course of her career, she changed not only the art style but also her name from Gesinger, her first husband's name, to Askew, her second husband's name, and finally back to her maiden name Bauer. Every name represents an episode in her life and in her art work.

All her later work involves different media – works on canvas – objects – videos – computer-created works – photography. She loves experimenting and exploring new fields like, for example, composing the sounds for her video installations. When she started working with computer-generated sound, it was learning by doing that she enjoyed tremendously.

Even though Eva Bauer is very consistent in her work as an artist, over the years she liked changes in her surrounding environment. She lived and worked in different locations, like Ibiza, Munich, then Berlin, back to Munich again and now dividing her time between the Black Forest in Germany and a small Caribbean island in Mexico.

Over the years her work has been shown in museums and galleries in Germany, Spain, Poland and Austria.

Life is chaos and in her art works she brings order into that chaos.

## Information on the Art Works

| | | |
|---|---|---|
| Cover Photo | | Ones to a Square with Gap, 2 parts, 40 x 40 cm, wood |
| Pg. | 9 | Studio Berlin, Oberschöneweide, 2009-2012 |
| Pg. | 11 | Exhibition 48 Künstlerpositionen, Modern Art Museum, Hünfeld, 2010-2011 |

### Paintings Acrylic on Canvas

| | | |
|---|---|---|
| Pg. | 13 | Double Seven, white – 160 x 160 cm |
| Pg.. | 14 | Double One, black negative, 100 x 100 cm |
| Pg. | 15 | Tessellation with One, white, 30 x 30 cm |
| Pg.. | 16 | Tessellation with One, series, 30 x 30 cm |
| Pg. | 17 | Blue Ones to a Square, 100 x 100 cm |
| Pg. | 18 | Blue One with Square, 100 x 100 cm |
| Pg. | 19 + 20 | Fragments of Seven, series each 80 x 80 cm |
| Pg. | 21 + 22 | Ones Towards a Square, series, each 40 x 40 x 5 cm |
| Pg. | 23 | Shape Disturbing a Square, 30 x 30 cm |
| Pg. | 24 | Off Balance, 30 x 30 cm |
| Pg. | 25 + 26 | Ones to a Square with Gap, series, each 100 x 100 cm |
| Pg. | 27 | Lying Eight Behind Squares, 100 x 100 cm |
| Pg. | 28 | Hidden Eight, 100 x 100 cm |
| Pg.. | 29 | Barcode Zero, 30 x 30 cm |
| Pg. | 30 | Pixel Zero, 160 x 160 cm |

### Objects

| | | |
|---|---|---|
| Pg. | 32 | Attempt to Build a Square Wall, size variable, wood |
| Pg. | 33 | Two Squares, floor sculpture, 115 x 115 cm, wood |
| Pg. | 34 | Assemblage, size variable, wood |
| Pg. | 35 | Cube Double One, 30 x 30 x 30 cm, wood, felt |
| Pg.. | 36 | Reflecting Ones, cube 12 x 12 x 12 cm, glass, metal |

### Video Sound Installations

| | | |
|---|---|---|
| Pg. | 38 | Multiscreen video installation, "Stripes", |
| Pg.. | 39 | Multiscreen video installation, "Black and Light" |
| Pg. | 40 | Multiscreen video installation, "Moving Light" |
| Pg.. | 41 | Multiscreen video installation, "Light Points" |
| Pg. | 42 | Multiscreen video installation, "Black One Jump" |
| Pg.. | 43 | Audio-visual room installation, "Reflection" |
| Pg. | 44 | Audio-visual room installation, "Open Walls" |

### Photography

| | | |
|---|---|---|
| Pg. | 46 | Photoprint, Emerging Light, |
| Pg. | 47 | Photoprint, Emerging Blue Shape |
| Pg. | 48 | Photoprint, Bending Stripes |
| Pg. | 49 | Photoprint, Crossing Shapes |
| Pg. | 50 | Photoprint, Disappearing Shapes |

### Computer-processed Print Edition

| | | |
|---|---|---|
| Pg. | 52 | Ones with Purple Rectangles |
| Pg. | 53 + 54 | Appearing,, Disappearing |
| Pg. | 55 | Blue Square with Round Shape Fragment |
| Pg. | 56 | Three Lines No Square |

www.ingramcontent.com/pod-product-compliance
Lightning Source LLC
Chambersburg PA
CBHW050858180526
45159CB00007B/2711